MAKE YOUR WATERCOLORS SING

LaVere Hutchings

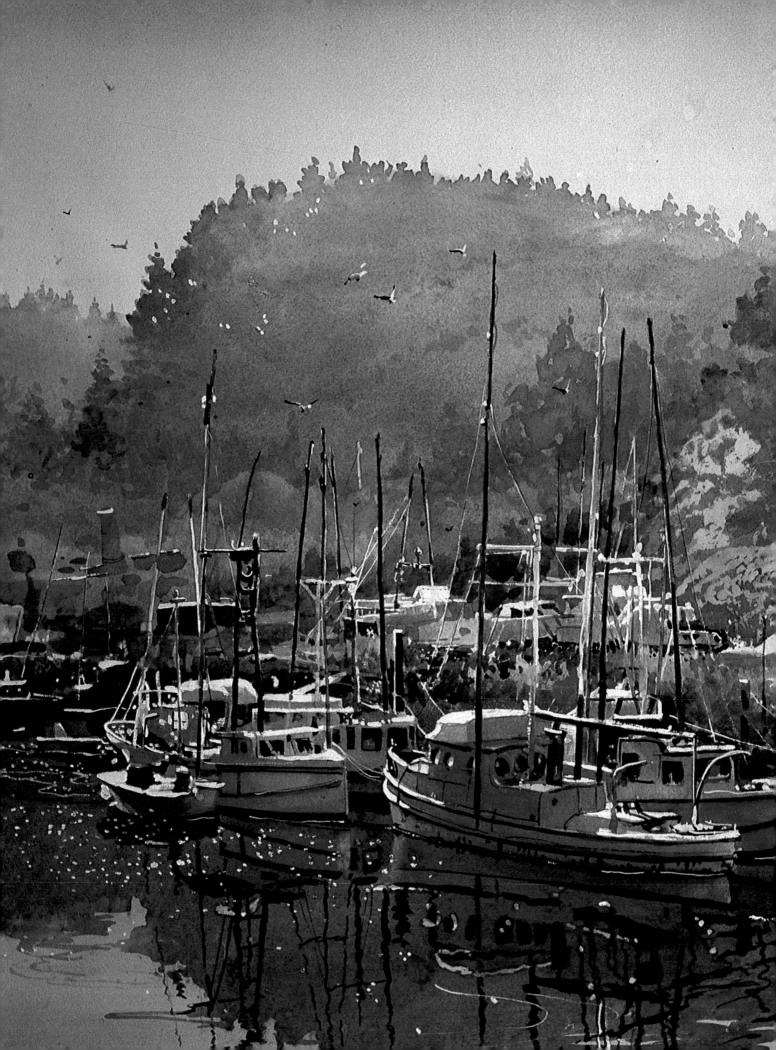

MAKE YOUR WATERCOLORS SING

LaVere Hutchings

Cincinnati, Ohio

"Boats near Mendocino"
22" × 30" watercolor
© Haddad Fine Arts, Inc.
Courtesy Tonian Hohberg Collection

Library of Congress Cataloging-in-Publication Data

Hutchings, LaVere, 1918-
 Make your watercolors sing.
 Bibliography: p.
 Includes index.
 1. Watercolor painting—Technique. I. Title.
ND2420.H88 1986 751.42′2 86-5228
ISBN 0-89134-132-3

To my dear wife, Anne, who really cares.

Acknowledgments

To my parents, Price and Mellie Hutchings, who taught me to always give my best.

To John Pike, who inspired me and was my friend.

To Hayward Veal, who opened my eyes and made it possible for me to really see.

To Tonian Hohberg for her support and encouragement through the years.

To Goldie Hales, who keeps saying, "Hey, Hutch, I got faith in you."

To Jim Haddad for his wise counsel and vision.

Special Thanks

To Fritz Henning, Editor, for his gracious professionalism and kind understanding.

To Val Gerstle, Editor, for her special help.

To Deborah Blevins for promotion.

Color photographs courtesy of Hackercolor.

"Mining Town"
11" × 14" watercolor
Collection of the Artist

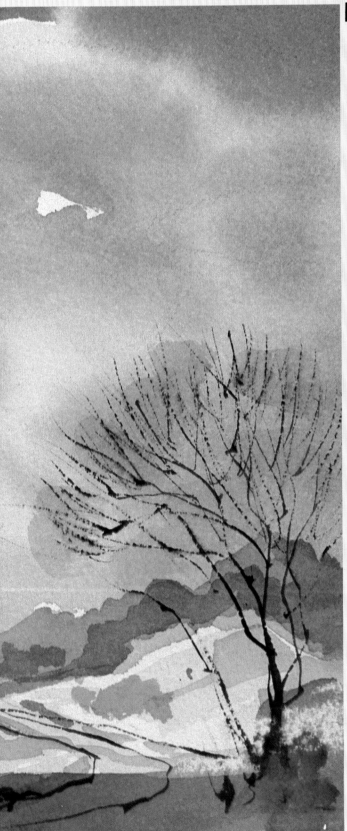

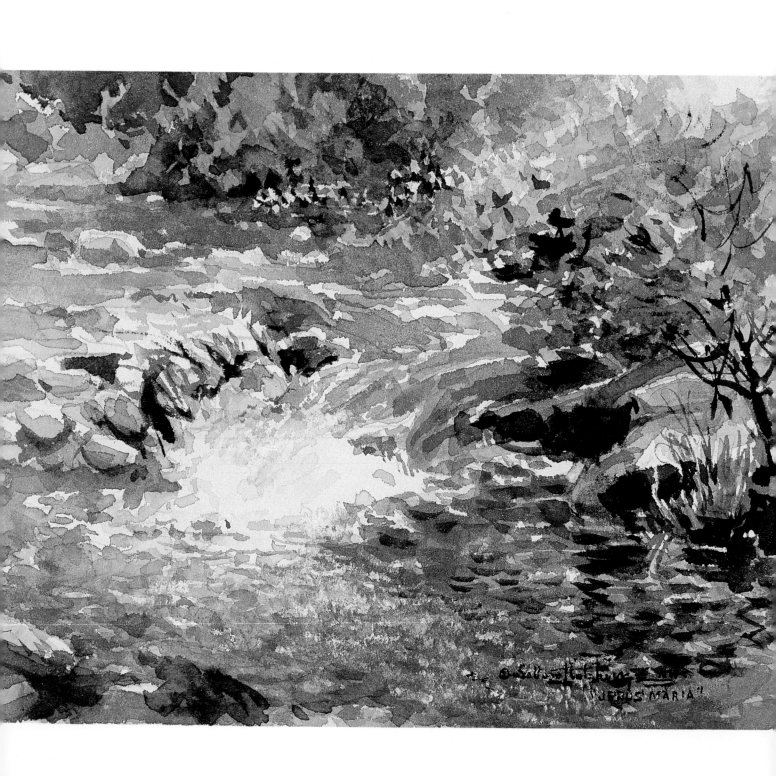

When pure, clean color is laid on white paper, a vibrating luminosity is born. Almost like the clear notes of a bell, a melody can be heard. Visually, the piece sings.

Many things influence the singing quality of a watercolor. Most important are fresh, clear colors. They need to be applied carefully to create color continuity and color harmony. In the color chapter I explain these terms, along with color-coding, a technique I use to achieve color continuity and harmony.

Part of using colors judiciously is practicing with all kinds of washes: flat, graded, stain, grainy, color-added, color-thinned, dry, wet-in-wet, and layered. You'll find them discussed throughout the book.

Glazes too are an important tool in my arsenal of techniques. They're explained in the glazes section.

A watercolor's success also comes from wise use of value relationships. Preliminary pen or pencil value sketches help me keep my watercolors from getting muddy as a result of too much scrubbing or too many glazes used to change incorrect values.

Light and shadow add pizazz and luminosity. They create depth and form. In every watercolor the presence of light—be it indirect, top, side, or back—helps create that special singing quality. You'll find light and shadow, along with how to evoke moods, discussed in the mood and lighting chapter.

Even more important than light is design. In the design chapter I explain balance, continuity, harmony, emphasis, and other principles.

The use of grays helps me emphasize and spotlight bright, pure color, making it luminous and vivid. In the section on grays I suggest ways to use them effectively.

The chapter on texture explains techniques for achieving texture, such as how to acquire it by using salt—a method I use a lot. Texture is a technique for achieving realism and for making your paintings interesting.

Through color continuity, color-coding, controlled washes, proper values, light and shadow, wise use of grays, mood, texture, and good design, I show you how I make my watercolors sing. Demonstrations detail steps of the painting process so you will understand how my paintings evolve. You'll find each heading uses a painting or demonstration to clarify its point. Some sections have additional paintings for further elaboration.

But remember: there's no *one way* to do a painting. Don't feel limited to my ideas; use them as a point of departure. Using my techniques along with your imagination, you too can make your watercolors sing.

"Jesus Maria"
6¹/₂" × 8" watercolor
Collection of the Artist

EQUIPMENT

The first step is to get acquainted with the materials you need. If you have experience, you'll probably already know what works best for you. However, if you're uncertain about your supplies or if you're just beginning, here's a good way to get started.

SUPPLIES

Almost everything you need is inexpensive and easy to find:

Water—I like to have at least a gallon on hand. I keep it in a plastic bucket. A plastic cup serves as dipper and container for cleaning and wetting my brushes.

Artificial sponge—The flat, oblong kind works well; mine's about four inches long. It's useful for sponging the paper off with clean water.

Soap—A bar of mild hand soap is useful for washing brushes.

Masking fluid—This is used to paint in areas where you want to retain the white of the paper. It enables you to paint over the masked area instead of around it. When your wash is dry, the masking fluid is easily removed, and the pristine paper awaits you. A *white wax crayon* is also useful for resist areas. You simply draw with the crayon on the paper. Your image will be nearly in-

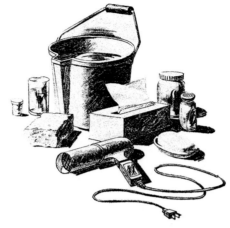

visible until you paint over it; then it will stand out as white.

Scraping tools—Various items—even your fingernails—can be used to scrape still-wet paint from the surface of the paper. Examples include: palette knife, pocket knife, razor blade, end of a brush, and wedge of mat board. Be creative: use whatever you have handy.

Paper towels and tissues—These are handy for picking up beads of excess water, dabbing out desired light areas, and also for general cleanup.

Salt—A shaker of table salt can help you create some exciting textures.

Hair dryer—A blast of warm air speeds up the drying time of wet washes.

Jar of premixed new gamboge—I often use undertones of this yellow to help establish the kind of color luminosity I like. Keep it in a jar with your basic painting kit.

Masking tape—A roll of this is handy for securing your paper to your drawing board.

Toothbrush—This can be used for spattering: dip the toothbrush in paint and drag your thumb across the bristles, spattering the color on a dry, damp, or wet paper—each with a different effect. This can also be done with clear water, which creates a balloon-like texture.

Stencils—Scraps of cut or torn paper, mat board, and masking tape can be used to block out areas to be kept clear of paint or spatter. For detailed stencils, masking tape can be cut into shapes and applied to the paper.

Drawing board—Wooden and Masonite drawing boards are available in art supply stores in a variety of sizes. Many artists prefer the smooth surface of Masonite or plastic sheets. I use a standard clipboard for pen or pencil sketching. In time, if you like to work outdoors, you'll also want a folding easel but that can wait. You'll soon learn what you like and need.

The importance of equipment:
For "Carmel," I used masking fluid and stencils cut from masking tape to help preserve the details of small areas such as the people and park bench while I applied washes to larger areas.

"Carmel"
15" × 22" watercolor
Collection of Mr. and Mrs. Harold Irwin

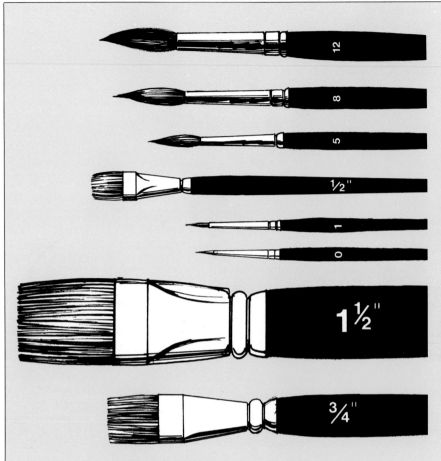

BRUSHES

These are some of my oldest friends.

The three round red sables are fine kolinskies.

The white bristle scrubbing brush is pig bristle.

The two tiny brushes are trimmed red sable watercolor brushes. I use them for masking and detail work. The smaller one is my signature brush.

The large flats are ox and sabeline. Both are at least 20 years old and still in fine shape.

PAPER

I learned about watercolor paper the hard way. For a long time I worked on inexpensive pulp paper. My paintings looked dead. I wondered how other artists could come up with such luminosity.

The mystery was solved when I began to use rag paper. I discovered that even a novice such as I could make accidental washes that were beautiful. From suppliers I found out about the top papers: Whatman, Arches, Fabriano, Magnani, and J. Green.

Eventually I decided to use nothing but 100 percent rag. I knew that paper has two potential work surfaces and that if a full sheet costs me X dollars, I gamble only half the price per side on half sheets and a quarter of the price per side on quarter sheets. Although the cost per sheet forced me to prepare thoroughly before painting, the economics weren't so staggering on a price-per-side basis. The paper is sturdy enough that if you mess up you can turn it over and paint on the other side.

I like to experiment on new paper. I must admit, though, that the brand I love most is 400-pound J. Green. It's heavy and workable and has a beautiful, sensitive surface. Arches 300-pound c/p (cold press) and 140-pound c/p are also good. 140-pound RWS (J. Green's Royal Watercolor Society paper) c/p, Fabriano, and Whatman are nice too. You'll learn good-quality watercolor paper is worth the price.

Dry Mounting

Wet Mounting with Tape

Wet Mounting with Staples

MOUNTING PAPER

Dry mounting—This is the quickest, easiest method. I don't soak papers that lie flat—papers like 300-pound Arches, 300-pound Saunders, or 300-pound Strathmore.

With Arches especially, I damp sponge both sides of the paper and let it dry before mounting it with masking tape to a piece of corrugated cardboard that acts as a rigid, lightweight painting board.

Wet mounting—It is necessary to stretch, then shrink certain papers, including 300-pound and 400-pound J. Green, RWS, Whatman, and Rives. Usually papers with scalloped or deckle edges require stretching. Most 140-pound and 90-pound papers do also. If I know that a particular brand is short on gelatin sizing, I will not soak it; I'll just let it stretch itself after a quick dunking in water. Esportizone is sometimes like this. I stretch most of my quarter sheets on shellacked, quarter-inch Masonite panels using one-inch butcher's brown tape.

Wet mounting with staples—Half sheets, full sheets, or larger ones are soaked and then stretched by stapling them to shellacked three-quarter-inch plywood. If the paper pulls away from the staples after it dries, I put masking tape over the edge to hold it down.

PALETTE COLORS

The palette I like has developed over the years through trial and error. At first, I used as many as twenty-five tube colors. After much muddy work, I pitched the whole batch and started fresh. At first I was frugal, using only the primaries. But my work wasn't what I wanted, and I wound up with eight colors. Then I added more reds. Today, I use *eleven tube colors.*

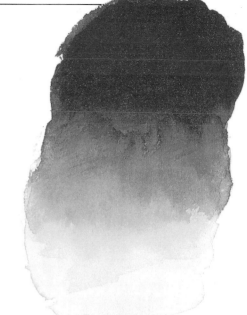

•*Scarlet lake*—A beautiful red, scarlet lake tends a little toward orange. I mix it with yellow for orange. When grayed, it works well for flowers, bricks, and skin tones.

•*New gamboge*—This is my only yellow. It's both transparent and staining, an excellent color for mixing. It's strong but will thin out to a lively pale tint. I use it with all colors and as an underpainting tone.

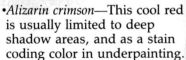

•*Alizarin crimson*—This cool red is usually limited to deep shadow areas, and as a stain coding color in underpainting.

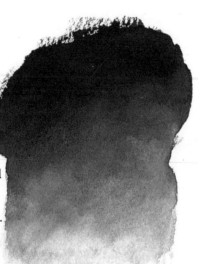

•*French ultramarine blue*—This color is warm and grainy. I use it for shadows, water, and skies. It makes a fine cloud shadow when mixed with earth colors.

•*Winsor blue*—This strong, cool blue is a must for my blue skies and turquoise water. It mixes well with all my colors. It's clear, staining, and good for glazing.

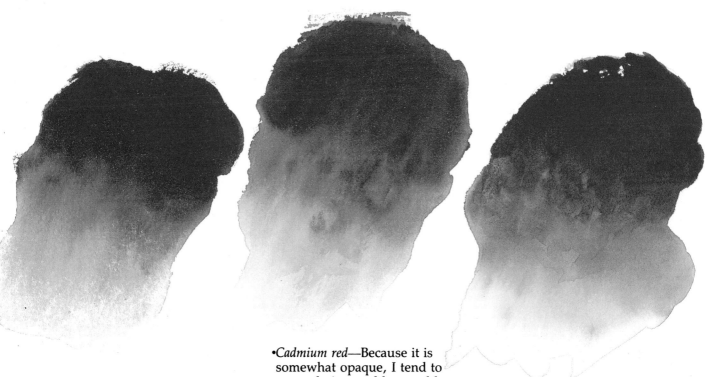

•*Cadmium red*—Because it is somewhat opaque, I tend to use cadmium red less and less, replacing it with thalo red.

•*Winsor red*—This strong staining color is good for underpainting and color-coding during a toning wash. It's beautiful for florals and decorative areas.

•*Permanent rose*—By itself, it's lovely, clear, and luminous. I mix it with French ultramarine blue for my favorite violet. It's beautiful in florals, portraits, and landscapes. It mixes well.

•*Burnt sienna*—This color is one of my favorites. Thinned and mixed with blues and greens, it has dozens of uses: shadows, glazing, detailed rendering, and granular washes.

•*Winsor green*—I mix Winsor green with yellow, red, and earth colors for foliage. It's lovely as a distant hill or tree mass when mixed with cool reds.

•*Burnt umber*—When thinned, burnt umber makes an excellent gray for soft shadows in skies. I use it with green for dark areas in foliage. It's a good dark for accents. It's grainy and mixes well.

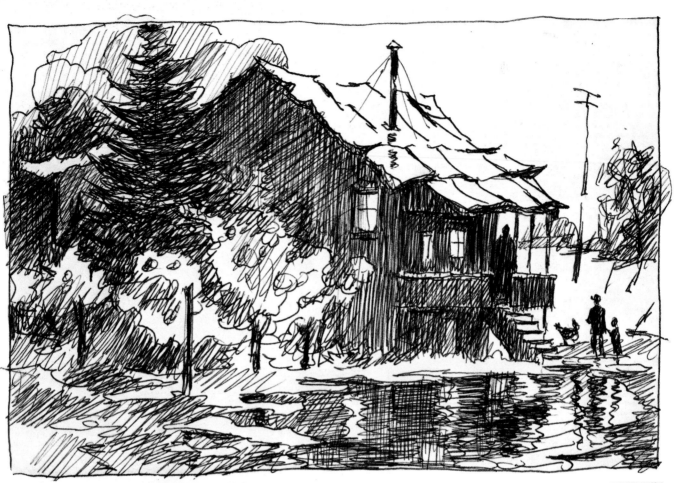

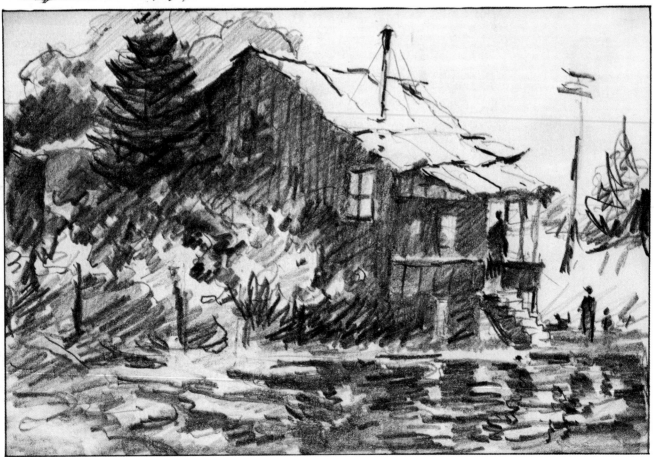

THE CREATIVE PROCESS

What is it that triggers creative juices? In my case making a living has to be one factor. However, a beautiful watercolor hanging in a show is also a powerful stimulus. It makes me want to go to my studio and paint. I feel like a starving man who sees food. A word of encouragement, a compliment—even a derogatory statement—will spur me on.

Nature is probably the most potent catalyst. An hour alone at the beach, along a river, or in a wooded area will recharge my creative batteries. Sometimes, just a fleeting glimpse of something will put an idea into my head.

HOW TO BEGIN— THE SKETCH

The preliminary sketch is essential. Without it, I wander like a nomad—with it, I have a blueprint to lead me out of muddle and confusion.

I prefer to sketch with pen or pencil.

Paper fastened to a clipboard

Should you use pen— or pencil?
The medium you use can have a dramatic impact on the overall effect you achieve. Note how the pen sketch (top) has a crisper, harder-edged look while the pencil sketch (bottom) retains a softer, smudgier feeling.

provides a great setup—portable, easy to handle, and private. More and more I sketch from my car. The steering wheel makes a suitable easel for my clipboard, and this gives me a weatherproof, bugproof place to work. It's like a miniature studio with soft seats, music, and views. I keep the car equipped for sketching, so when a subject excites me, I can stop and work.

My method of sketching is simple. First, I make several small, abstract line drawings to establish the basic design. For the finished sketch I add value, texture, and detail.

One important aim is to arrive at a center of interest. I don't know whether I find it or it finds me. Either way, it has to be the

dominant part of the sketch.

I like to do as much as possible at the sketch stage, indicating design, values, shapes, light and shadow, and detail. I paint directly from my sketches and rely heavily on them. Of course, I can't say everything in the sketch, so I leave something for the brush to create.

"Late for Dinner"
A photograph of a couple of children walking down the street triggered the idea for this painting. I used the little boy in this painting and the girl in another. The photograph and the painting of the girl are on pages 84-85.

"Late for Dinner"
15" × 22" watercolor
Collection of Joan and Andrew Nelson

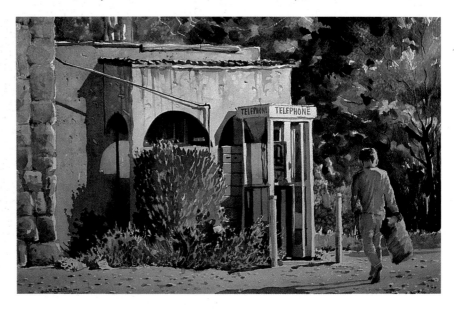

SAVING WHITES

I like to know where white areas will be before beginning a watercolor. If you look at these sketches creating interesting value shapes, you'll see how carefully the white shapes are planned. I often leave extra white areas—knowing that they may end up painted—as a sort of insurance. It's nice to have white areas to decide to use later on. It's easier to cover than uncover.

Masking is a procedure for saving critical whites, especially when more than one big wash will be used. Boat masts and rigging, figures, birds in flight, highlights on water, trunks, barbed wire, small pebbles, and other detailed subjects are good places to use a fluid masking agent. However, overuse of masking can become a crutch and may even detract from an otherwise loose, interesting rendering.

"Douglas Flat School"

The basic design of this painting is the large light shape of the school set against the dark background of trees. The structure is the dominant element, but the figures add life and make the scene interesting.

The placement of the figures was done to carry the observer's eye towards the schoolhouse. Notice how the movement from right to left is stopped at the left margin by the position of the horses and vertical tree trunks; thus the viewer's eye is turned back to the circle of interest.

Saving white using a pen and circling the center of interest

"Douglas Flat School"
15" × 22" watercolor,
300-pound Arches cold press
Collection of Grace and Owen Karstad

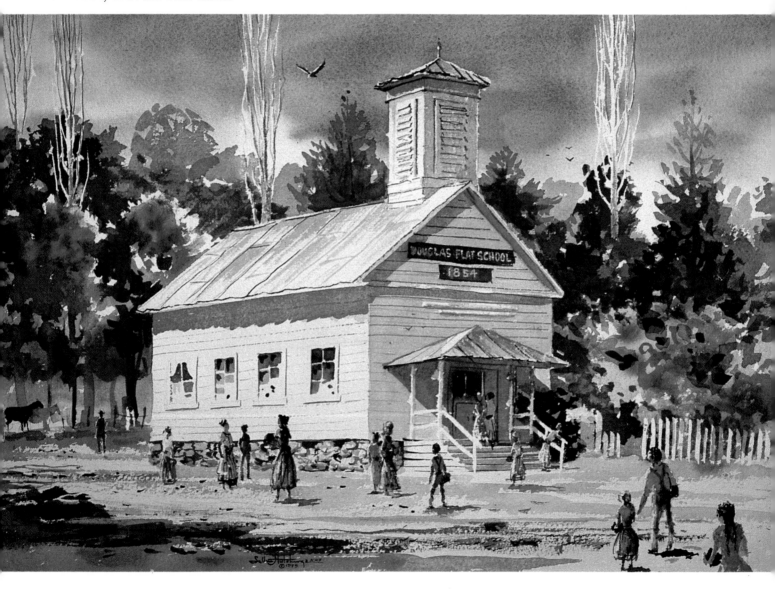

HAPPY ACCIDENTS

The spontaneous, accidental quality of watercolor is one of the things that makes it such an exciting medium to work in. Accidents are possible in any medium, but they seem particularly probable in watercolor, perhaps because of its watery consistency and the fact that the paper can be worked on wet.

Despite my love for the effects you can get from accidents, I use them sparingly—in foregrounds, backgrounds, or other limited areas. Overuse of accidents can make paintings look like accidents. Have you ever heard someone staring at a painting in a museum say, *"I could do that!"*? That's the reaction you'd get if you based your work on accidents.

I have two primary ways I encourage accidents. One is to keep my paint kind of runny and apply it directly to wet paper. This technique is called wet-in-wet (wet-in-wet can also be done with thicker paint stroked onto wet paper). A couple of examples are *Rhapsody* and *Late March.* See pages 30 and 110-111.

My other method is to use salt to create surprising textures. I will discuss this in detail later in the book. An example of a painting done using this method is *Golden Autumn.*

Other items you might want to try adding to your paint to get unusual effects are sand, wax, turpentine, and soap. Use your imagination: you can probably come up with some of your own.

"Golden Autumn": An example of a happy accident

I let the "happy accident" (salt sprinkled into a damp wash) that caused the interesting texture of the leaves dry before painting in the trees and road.

"Golden Autumn"
14" × 22" watercolor,
400-pound J. Green cold press
Collection of the Artist

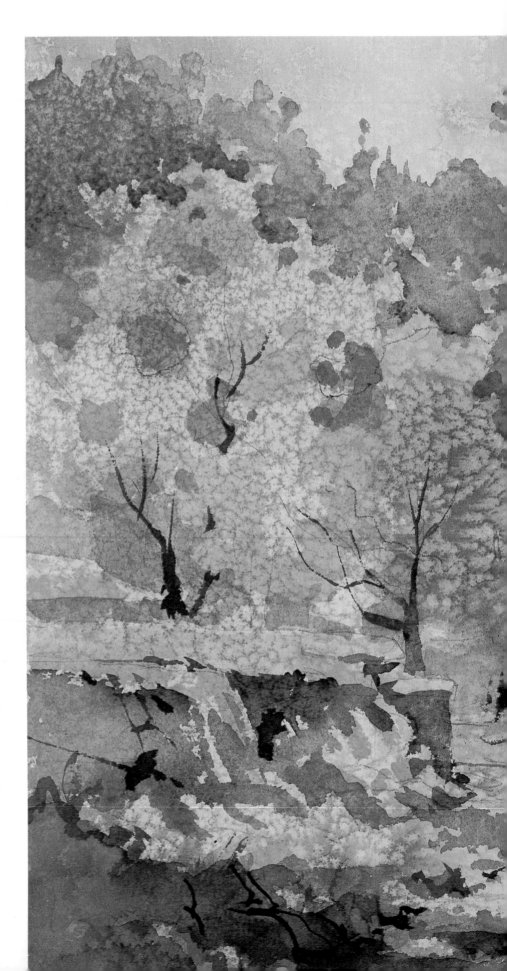

3

DESIGN

All good paintings are done on the basis of good design. Effective design is seldom come by accidentally. I often spend hours doing thumbnail sketches before choosing one as a model for a finished sketch. Only then do I tackle the watercolor.

A design is the blueprint or pattern for the painting.

PRINCIPLES OF DESIGN

Balance

If a picture is clearly balanced when we view it, we feel secure and satisfied. But if this stability is too obvious, we're bored. Most pictures are created with an informal balance, where the elements aren't mirrored top to bottom or side to side as in formal balance. Informal or occult balance is more exciting, suggesting movement and spontaneity.

Balance or equilibrium is usually accomplished by mentally weighing areas of value, color, and texture against one another. Large light areas balance small dark areas. Placement of objects in a negative field can create balance if they are properly related in size and value. A small spot of pure color will be balanced by a

larger area that has been diluted. Gaudy areas need to be handled judiciously so that gray areas are not overwhelmed. Balance means equilibrium of color too.

Continuity

Organized movement or rhythm in placement of elements in a picture is called *continuity*. Like the repeated theme in a melody, continuity is usually established through repetition that is made interesting through variation and alteration.

Harmony

Harmony is the desired end result of all pictures. Every element should fit together in a unified whole. When colors, values, shapes, and textures hold their proper place in a picture, it will be in harmony. Nothing needs to be added or taken away.

Emphasis

All areas of a picture should not have equal emphasis. To do so would be like having all instruments in an orchestra play at maximum strength at the same time. The result would be deafening, unsubtle, and unsatisfying. The eye, too, responds to variety. For a form to appear visually dominant, it must be juxtaposed with areas that are recessive. Good pictures depend on such variety.

"Grandpa's Wagon"

Because of the asymmetrical placement of the barn, the design of "Grandpa's Wagon" could be called *informal* or *occult*. The placement of the wagon and its reflection in the puddle help create a sense of balance by keeping the barn from becoming overpowering. The background details of barn, mountain, and telephone poles also contribute to this effect, creating a pleasant sense of balance.

Imagine this painting with everything removed but the barn. Do you see how the design would seem lopsided? After you learn the principles of design, they'll seem like common sense.

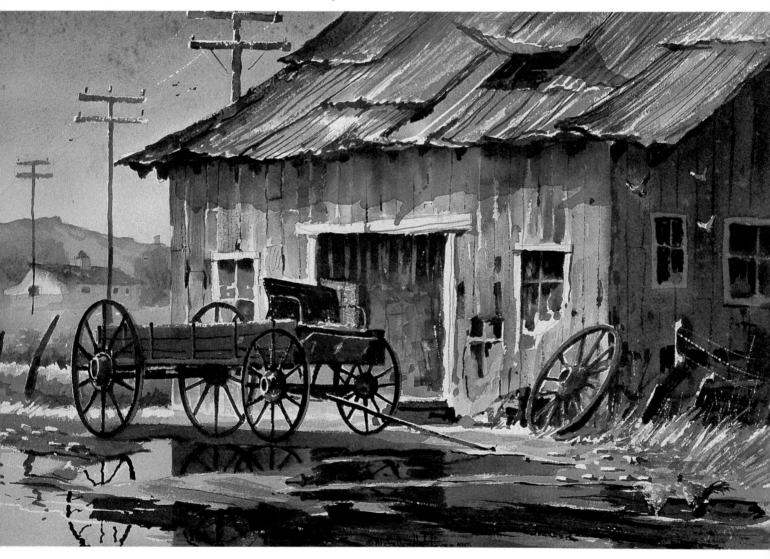

"Grandpa's Wagon"
15" × 22" watercolor
Collection of Dr. and Mrs. Denver Perkins

Figure 1. Negative shape

Figure 2. Related interlocking elements to create opposition

Figure 3. Dark and middle values used to unify picture

DESIGNING WITH NEGATIVE SPACE

Negative space is the area in a picture not occupied by a (positive) form. It's the neutral background around a form. Looking for and using negative space is as important in designing as considering shape and proportions of positive forms. Here is an example of how I find negative shapes useful in planning the design of a picture.

Figure 1.

By creating three negative shapes that are not equal in the planned picture area, I establish three abstract elements to serve as a basis for the design. I try to keep these shapes unequal in size, dissimilar in contour, and yet in harmony because of the nature of the line.

Figure 2.

This skeletal structure can be the basis for unifying the composition.

The next step is to develop related, interlocking elements to provide counterthrust and movement.

Figure 3.

Finally, dark and middle values are added without destroying the flow and movement of the original negative shapes. The puzzle becomes more complex as the dark shapes begin to take over and compete with the white shapes. At this point one begins to move and adjust all the elements in the picture to achieve proper balance of positive and negative space.

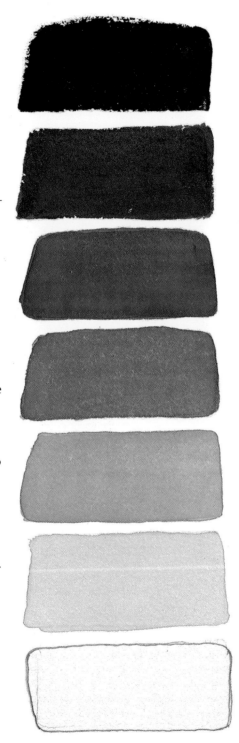

A VALUE SCALE

Making a value scale can be a creative exercise. And a finished scale will prove useful for future reference.

Following are instructions for creating a step-by-step gradation of value from black to white with five steps between. A color can be substituted for black if you wish, but stay away from yellow. It presents special problems because of its lightness.

Begin with a fairly large puddle of pure color. Paint in your darkest value—here the black at the bottom of the swatches. Then add a brushful of water to each succeeding value as you move up the scale. Sometimes a value can be lightened by wiping the water out of the brush, tipping the paper and picking up the bead that forms at the bottom of the wash. While the wash is still wet, you can brush more of the mix into it. You can also use the point of a loaded brush with the same mix to stipple into a wet wash if it needs to be darkened slightly.

Create a value scale
Create a value scale by starting with a puddle of color and adding water for each succeeding value.

DESIGNING WITH WASH VALUES

Step 1.

It's important to plan how light or dark each area of the painting will be. Work out a pen or pencil sketch to serve as a plan for placement of shapes and values.

The first step in this picture was to wash in the sky tones, side of the building, and trees and foliage. Since no masking was to be used, all the white areas had to be left untouched. This was done by painting around them. The light source was from above, so most of the whites were on the tops of bushes, post, grass, steps, and roof.

Step 2.

Next a dark value was washed onto the sides of the house. The pine tree was added, but this tone seemed too dark. I lifted off some of the wash with a damp sponge and tissues. Corrections can be made in watercolor, but they take care and practice. Additional tones were added to the house and boards and shingles on the roof. I also made some adjustments in the background trees.

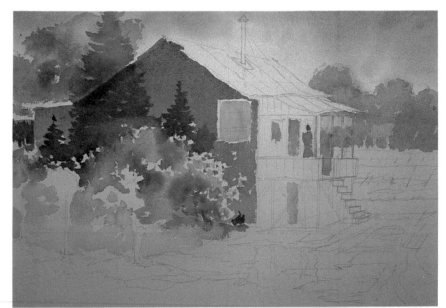

Step 1

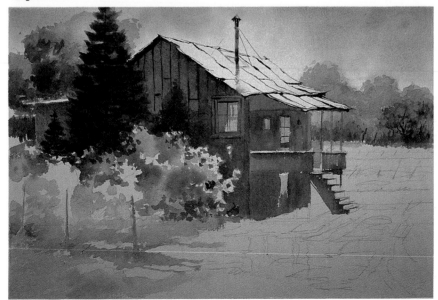

Step 2

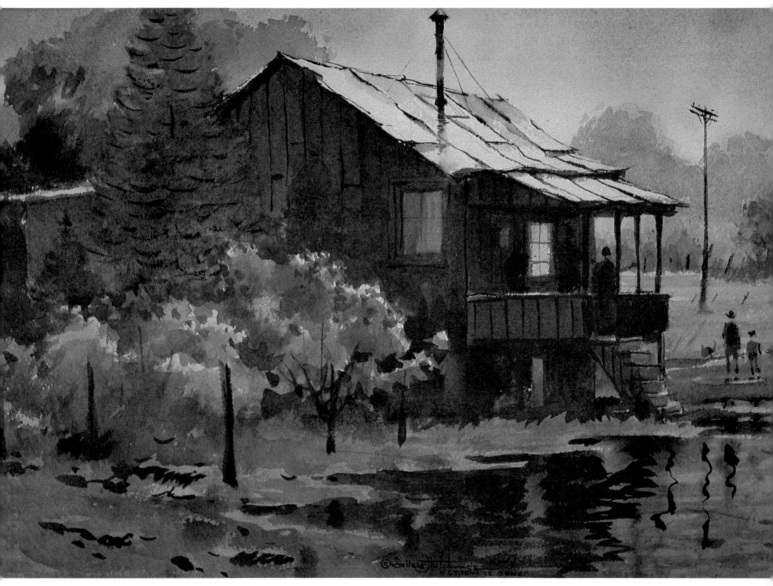

Finished painting

As the undertones dried, more darks were added to the structure and, in particular, the foreground puddle. Finally the people were added, along with the telephone pole and fence posts.

You can see by this example that if your sketch works in black and white, it has a good chance of success in color.

"Old House in the Rain"
22" × 30" watercolor,
300-pound J. Green cold press
Collection of the Artist

COLOR

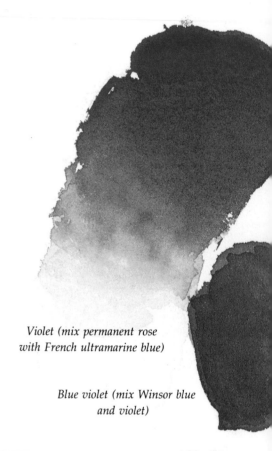

Violet (mix permanent rose with French ultramarine blue)

Blue violet (mix Winsor blue and violet)

Some sage once observed that a world without color would be like a body without a soul. Fresh, clean color on white paper is exciting. It reminds me of rainbows and flashes from diamonds.

It's important, though, not to use too many colors. I've never learned to handle twenty or twenty-five tube colors. I get confused and feel overwhelmed. Eleven's my magic number. Limiting the number of tube colors I use helps me keep my colors fresh.

COLOR MIXING

Some things are better demonstrated than described. A case in point is achieving the color mixtures in a painting. In most cases, there's no precise formula that can be codified for easy future use. The artist is more like a good cook adding a little of this and a dash of that.

In a painting demonstration I can show students how to mix yellow ochre with ultramarine blue. They see that I simply touch my brush to the yellow and add it to a large amount of blue. If the effect is not quite green enough, I'll add more yellow. But how do I get this across to the serious reader who needs to know how to arrive at a somewhat similar color?

To help solve this problem, I'm including examples of my basic approach to mixing colors. As much as possible in the coming text, I'll attempt to tell you the general proportions of the mixtures I describe.

Color Wheel

This color wheel is made from my working palette. Each color is clean, bright, and transparent. No grays are shown, because no complements were mixed together. All twelve colors can be intermixed successfully. Opposites will neutralize each other and become grayed. Adjacent colors mixed will remain clear and clean.

Winsor blue

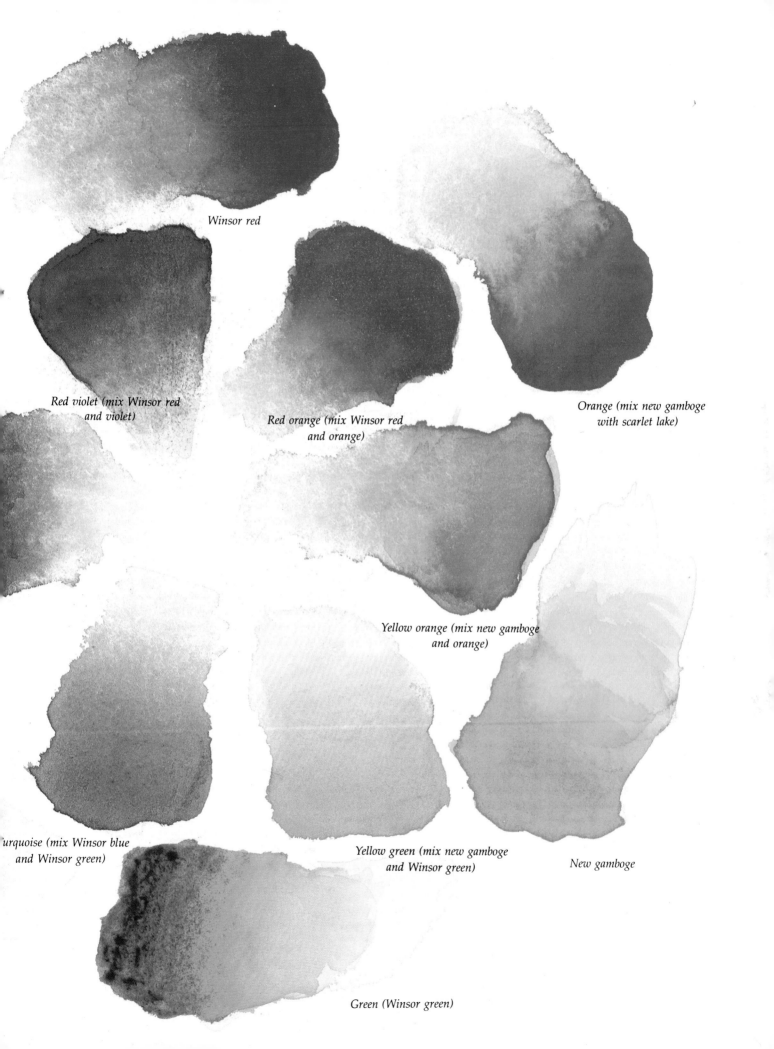

Winsor red

Red violet (mix Winsor red and violet)

Red orange (mix Winsor red and orange)

Orange (mix new gamboge with scarlet lake)

Yellow orange (mix new gamboge and orange)

urquoise (mix Winsor blue and Winsor green)

Yellow green (mix new gamboge and Winsor green)

New gamboge

Green (Winsor green)

COMPARING COLORS

To understand how colors work together and react to surfaces, we need to know their physical qualities: they may be classified as either stain or grainy.

Stain Colors

Stain colors are those that seem to penetrate and are hard to wash off. Even in mixes, they have these characteristics. Some are more potent than others, and the phthalocyanine colors are especially strong. When it comes to staining power, thalo blues and greens, once put on watercolor paper, are there to stay. Some of the reds—permanent rose, scarlet lake, cadmium red—are not as hard to remove, but they still stain. Alizarin crimson and Winsor red are the strongest stainers—the hardest to get off. New gamboge yellow is strong, but some of it can be scrubbed off by wetting with water and scrubbing gently with a stiff, half-inch bristle brush, then dabbing with a tissue.

Grainy Colors

Grainy or sedimentary colors usually have little or no staining power and can be removed by carefully wetting them and dabbing them off with a sponge or tissue. When stain colors are mixed with them, they may not come off so easily. Each combination has its own characteristics in removal from paper. Colors that include phthalocyanine (called *Thalo* by Grumbacher and *Winsor* colors by Winsor & Newton) will be difficult to remove. Some of the color will scrub off; how much will depend on the paper you use. Arches is tough and scrubbable, while Whatman (new format) R.W.S. and Gemini will "scuff up" and hold the colors.

The characteristics of grainy colors result from the coarseness of some of the granules of pigment in the tube. These colors include French ultramarine blue, burnt sienna, burnt umber, cobalt violet, yellow ochre, and manganese blue. When a wash òr glaze is made with one of these colors or a mix containing one, it tends to granulate. The bigger grains of color settle into valleys of the watercolor paper, collect there, and result in a pattern of irregular specks, spots, or darker blips.

Some of the early English watercolorists looked upon this granulation or sedimentation as "mannered and pretentious." Today, artists use it to create mood, texture, and variety—all part of an artist's arsenal to enhance a picture. If granulation is overused, it can become boring. A little of it will sometimes appear accidentally, but many times we find this kind of accident the most exciting kind. Tipping the paper about 25 degrees after putting on a grainy wash or glaze will promote settling of sediment.

Mixing Grainy and Stain Colors

One can mix grainy and stain colors, but it's important to anticipate the results. Will the mixture stain? Can I get it off? Will it granulate? Is it transparent enough to allow bottom layers of color to show through? There are no hard and fast rules of proportion for mixing colors, so a little experimentation is often in order.

Overglazing

With layering of color, subtle color changes and interesting effects appear.

"Mother Lode Road"

"Mother Lode Road" was done mostly in stain colors, except for a few glazes of burnt umber and burnt sienna for the posts and tree trunks and accents.

"Mother Lode Road"
15″ × 22″ watercolor,
300-pound Arches cold press
Collection of Andrew and Joan Nelson

Useful color mixtures
Mixed from pure transparent tube colors.

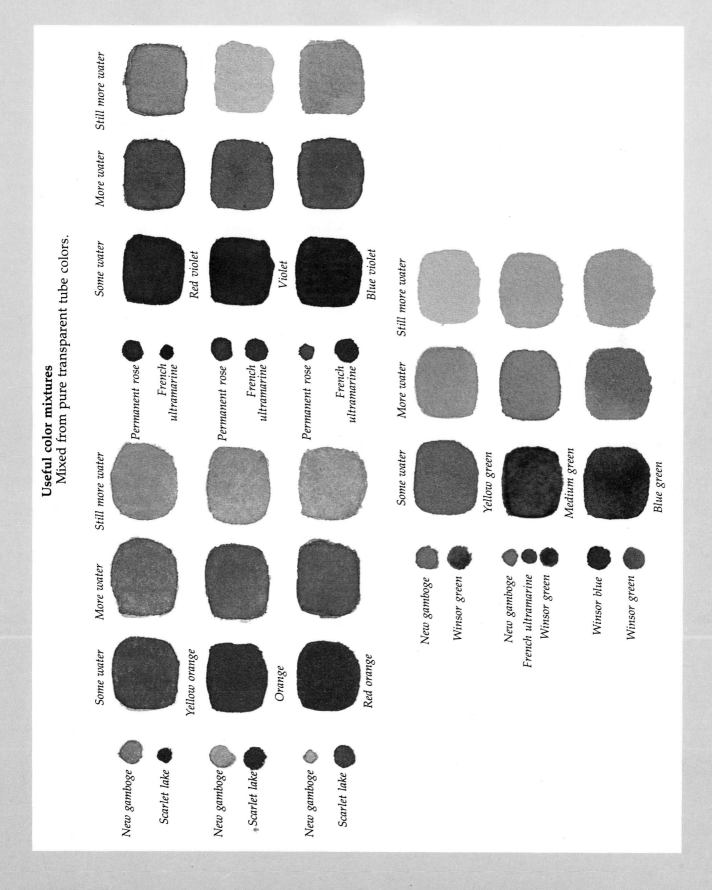

A BASIC PALETTE

(Designated either stain or grainy)

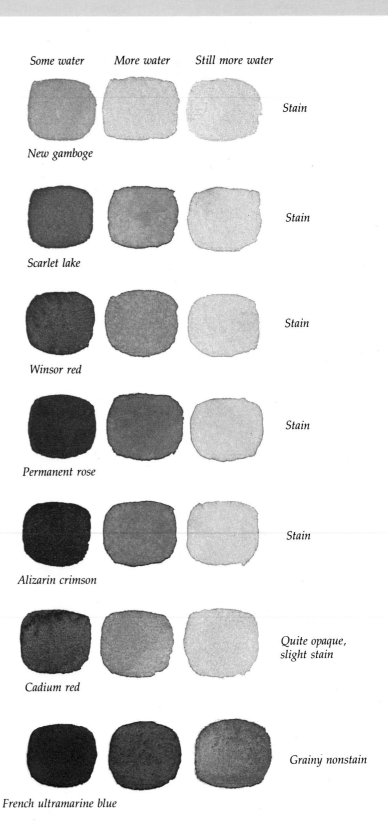

Some water More water Still more water

New gamboge — Stain

Scarlet lake — Stain

Winsor red — Stain

Permanent rose — Stain

Alizarin crimson — Stain

Cadium red — Quite opaque, slight stain

French ultramarine blue — Grainy nonstain

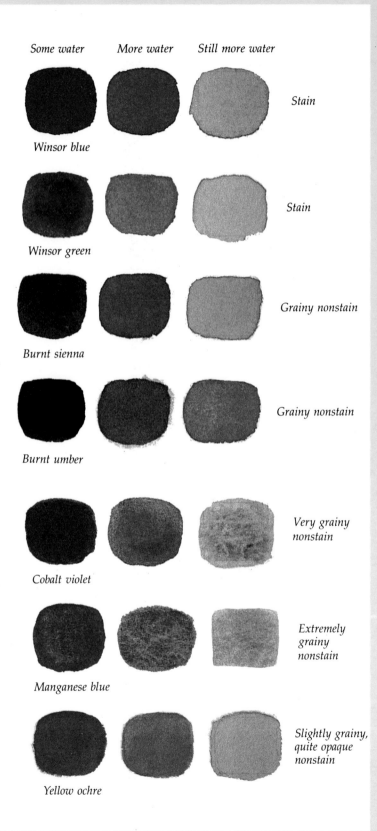

Some water　　*More water*　　*Still more water*

Stain

Winsor blue

Stain

Winsor green

Grainy nonstain

Burnt sienna

Grainy nonstain

Burnt umber

Very grainy nonstain

Cobalt violet

Extremely grainy nonstain

Manganese blue

Slightly grainy, quite opaque nonstain

Yellow ochre

Additional colors

Yellow ochre from the tube is opaque at full strength. In most cases, I prefer to mix a more transparent color from one part new gamboge plus one part burnt sienna plus a touch of burnt umber.

MIXING GRAYS

Learning to mix grays is a valuable skill. I learned it the hard way—by trial and error. But studying the chart titled, "Useful warm grays," you'll be able to learn the principles more quickly.

The grays in the chart are mixed from complementary colors—colors opposite on the color wheel—for example, red and green, blue and orange, and yellow and violet.

The center of each disk shows the gray that results from mixing pure tube colors on the left and right. The lighter gray shadow beneath each disk was made by adding water to the darker gray.

Useful warm grays

1. Winsor red + Winsor green
Creates cool grays for distant trees and warm, reddish grays for buildings, skies, etc.

2. Burnt sienna + Winsor green
Excellent for varied foliage colors; goes from warm to cool.

3. Burnt umber + Winsor green
Darker, heavier greens are somewhat neutralized; the gaudiness is killed.

4. Orange + Winsor blue
I use this gray for foliage and warm shadows.

5. Burnt sienna + Winsor blue
This is a darker, less luminous gray.

6. Burnt umber + Winsor blue
A delicate mix creates a very lovely shadow for clouds and makes distant hills move back.

7. Orange + French ultramarine blue
Beautiful for delicate orange tones against blues. It tends to get brown as it warms.

8. Burnt sienna + French ultramarine blue
My favorite gray. I use it wherever I can. It is a neat mix and creates a grainy texture.

9. French ultramarine blue + burnt umber
This mix is extremely useful in delicate skies, earth tones, and buildings.

10. New gamboge yellow + violet
Also a favorite. It can be mixed with a touch of French ultramarine blue or burnt sienna for mauves.

11. Burnt sienna + violet
Another lovely, warm rosy gray for clouds, earth, buildings, and portraits.

12. Burnt umber + violet
This mix, when greatly thinned, is terrific for glazes and delicate shadows.

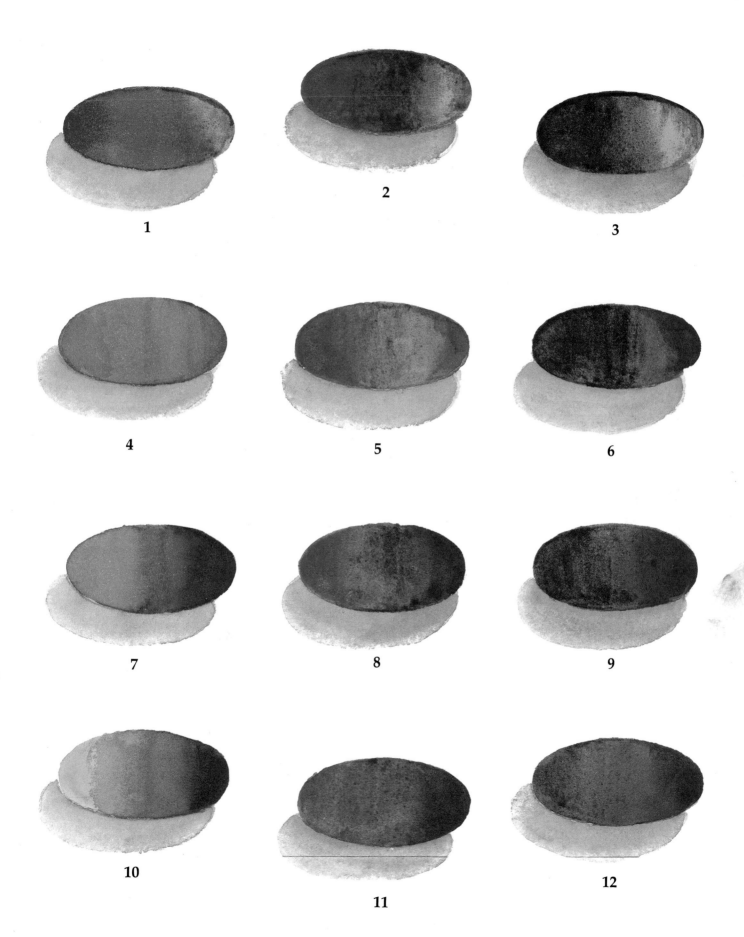

Colors grayed by adding earth colors or complementary colors

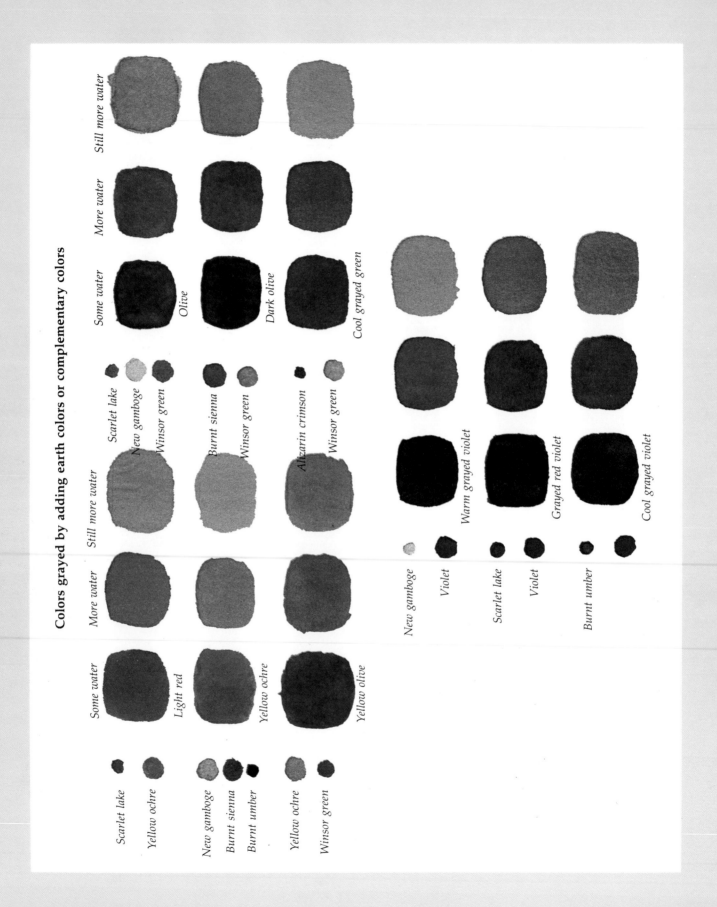

"Weed Patterns": An example of colors grayed by adding complementary colors

This is an old miner's shack in Nevada. In order to make the building look weathered from the strong Nevada sun, I had to gray the colors by adding complementary colors. On the area under the four windows I used burnt umber and grayed it with violet, which is a mixture of French ultramarine blue and permanent rose. On some of the other boards on the building I used burnt sienna, graying it with ultramarine blue. I also used a little burnt umber to gray the sky so there would be color harmony between the sky and the building. The posts and dark accents were done with burnt umber grayed with a little touch of French ultramarine blue.

"Weed Patterns"
22" × 30" watercolor
Courtesy of Las Vegas Art Museum

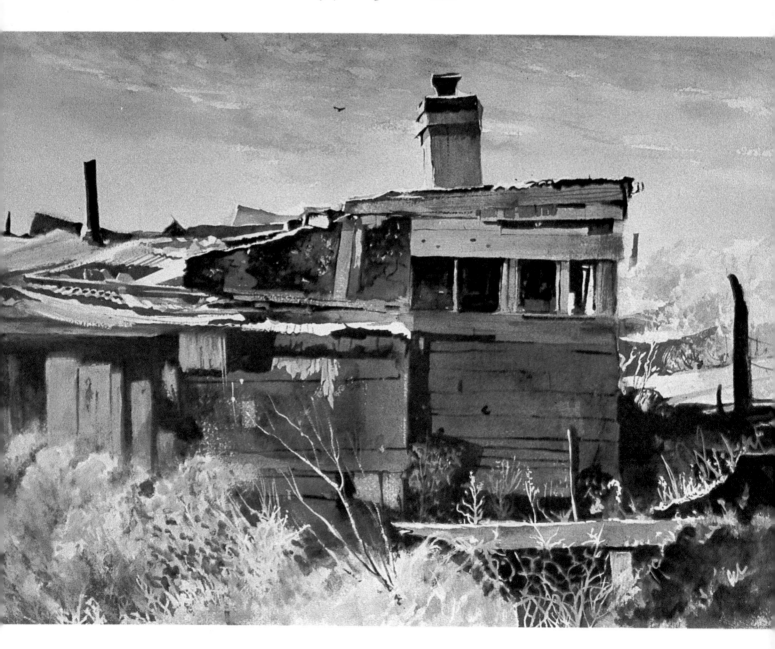

THE IMPORTANCE OF GRAYS

The dictionary defines gray as a color between black and white. My own definition is: a color mixed from any two complements.

Grays carry warmth or coolness through a picture like threads in fabric—a sort of weaving through and around brighter colors. Properly using gray is essential. Gray has been called the binder, glue, or cement that ties a painting together. When grays succeed, the chorus of colors is balanced and harmonious.

"Rhapsody": A painting done in soft, wet-in-wet grays

After the design was penciled on, I gave the sky and water a pale yellow wash, painting around the white areas, leaving them as negative space. I used the side of my one-inch flat brush to scumble—which means quickly going over the rough watercolor surface, just hitting the grain, resulting in an irregular jagged edge.

While the yellow wash was wet, I brushed in a mix of middle value burnt umber and middle value blue violet at the top and bottom of the paper, letting them blend into the yellow wash. The blending resulted in a graded wash from dark to light which is evident from top down and bottom up. A graded wash was created at the horizon by brushing in a pale cadmium red wash.

I brushed darker color into the original wash, letting it blend into the yellow, creating more graded washes. While all this was wet I took middle value burnt umber and brushed in the big tree masses. The edges of these large shapes blended into the sky, creating soft fuzzy edges, which again created graded washes from dark to light.

This painting was done wet-in-wet (painting additional color into an already wet area); that's why it's so soft.

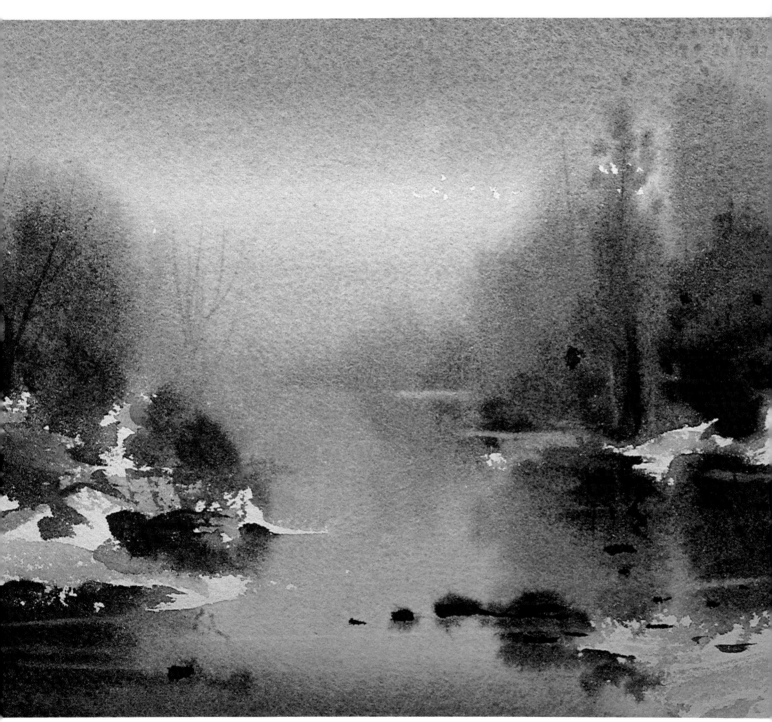

"Rhapsody"
12½" × 22" watercolor,
300-pound Arches cold press
Collection of the Artist

OVERGLAZING

Color glazed over another dried color

Here's what happens when the underlying color is not dry when glazed over.

One color glazed over two other colors (each color was dry before it was glazed over).

You may sometimes want to achieve special effects by glazing over a damp wash. However, for most glazing, be sure the underwash is dry. One trick for testing dryness of a wash or glaze is to place the back of your three middle fingers carefully against a surface that you think is dry. If it's *cool*, it should dry a little more. Use a hair dryer or leave it in the sun or breeze for a while longer, depending on temperature, humidity, and the thickness of your paper.

WASH EFFECTS

There are three main kinds of wash effects: flat, graded, and wet-in-wet.

Flat wash—An even tone of the same color or value

Graded wash—A uniform gradation from light to dark or dark to light in a given color or value

Wet-in-wet—Accomplished by applying one wet wash over another wet wash or by dropping color on moistened paper. The results can be unpredictable, as the paint tends to make its own pattern, but with experience you learn what to expect.

Flat wash

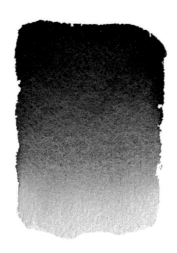

Graded wash

Wet-in-wet wash

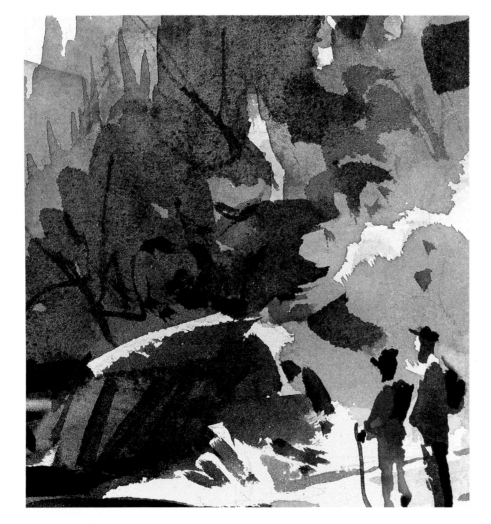

"The Hikers": An example of color layering

This is an example of what happens when layering of color—or glazing—takes place. Subtle color changes and interesting values appear. Notice the receding effects of cooler color as it gets paler and bluer with distance. The economy of using a maximum of three glazes has kept the color fresh and luminous.

"The Hikers"
4" × 5" watercolor,
330-pound Arches cold press
Collection of the Artist

PAINTING OVER A GRAINY COLOR

The terms *grainy*, *sedimentary*, and *granular* are interchangeable. They all mean the same. However, I like to use the term *grainy* because it's shorter.

At times it's necessary to put a layer of color—or glaze—over a grainy color, for shadows or value and color changes. It's not always possible to put down a staining color first, although it's the safest and easiest procedure.

If we *must* glaze over a soft, tender grainy passage, there is a way to do it successfully:

1. Mix more color than is needed.
2. Load the biggest brush that can be used.
3. Go over an area *only once*. If you make two passes, you'll lift the color.
4. *Don't go back into it. Let it dry!*

Figure 1.

Initial wash	*burnt umber*	Grainy
First glaze	*scarlet lake*	Stain
Second glaze	*French ultramarine blue*	Grainy

Figure 2.

Initial wash	*violet*	Grainy
1 part	*permanent rose*	
1 part	*French ultramarine blue*	
First glaze	*new gamboge*	Stain
Second glazes	*yellow green*	Stain
1 part	*new gamboge*	
2 parts	*Winsor green*	

Figure 3.

Initial wash	*permanent rose*	*Stain*
First glazes		
A	*burnt sienna*	*Grainy*
B	*dark olive*	*Grainy*
2 parts	*burnt umber*	
1 part	*Winsor green*	
Touch	*permanent rose*	

The initial wash of permanent rose influences the layers over it. Both glazes become warmer and redder. (Had I used a green wash in place of permanent rose, the glazes would become cooler and greener.)

Figure 4.

Initial wash	*violet*	*Grainy*
1 part	*permanent rose*	
1 part	*French ultramarine blue*	
First glaze	*yellow orange*	*Grainy*
1 part	*new gamboge*	
1 part	*burnt sienna*	
Touch	*permanent rose*	
Second glaze	*permanent rose*	*Stain*

One area had more water added

This is an example of how beautiful a grainy wash can become. It influences each layer of transparent color glazed over it. Permanent rose is mixed in all layers.

Figure 5.

Initial wash	*thalo green*	*Stain*
First glaze	*scarlet lake*	*Stain*
Second glaze	*blue green*	*Stain*
1 part	*Winsor blue*	
1 part	*Winsor green*	
Touch	*scarlet lake*	

Four new colors are added in this process, making a total of seven. If complementary colors are used initially, like red and green, plus a harmonic blue green, the new colors all become harmonious.

Figure 6.

Initial wash	*yellow ochre*	*Grainy*
First glaze	*violet*	*Grainy*

The same mix as used on Figure 4. The pattern is different because of different watercolor paper.

Second glaze	*red orange*	*Stain*
2 parts	*scarlet lake*	
1 part	*yellow ochre*	

By adding a color that is somewhat opaque, like yellow ochre, I wound up with a glaze that was not as clear as the stain glazes. It grayed the mix slightly but still let the layers below show their outlines and colors.

THE EFFECT OF PAPER ON WASHES

Paper surfaces affect the finished wash or glaze. On smooth, hard surfaces such as hot press, colors seem more intense because the pigment stays on the surface. Papers with a lot of sizing (such as any Arches paper) also tend to keep the color on the surface. Soft, porous paper such as Strathmore Gemini absorbs the pigment, softening the intensity and making it less brilliant. Extremely rough papers such as 400-pound cold press break up the color so the artist needs to use more to achieve the same brilliance as that from a smooth, hard surface.

Some artists prefer to work on nothing but hot press because it makes their work more brilliant. But I prefer cold press because of the texture I can get.

When it comes to granulation, rough surfaces tend to be more efficient because of hills and valleys in the paper. Speaking again of hard-and-fast rules, there are none for achieving a perfect granulated passage (see page 22).

Detail of "The Sun Came Out": An example of paper with a hard, smooth surface

This was done on a hard, smooth surface—not hot press, but Magnani Corona, a paper a lot like hot press. This type of paper causes the color to stay on the surface, rather than sink into the paper, which makes it appear more intense.

Detail of "Condon's Market": An example of paper with a lot of sizing

This was done on 140-pound cold press Arches paper. The colors are vivid because even though it's cold press and has a slight texture, there's a lot of sizing in Arches paper. Sizing keeps the paint on the surface, preventing it from sinking in.

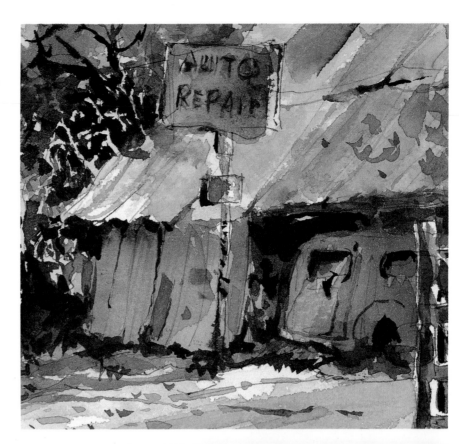

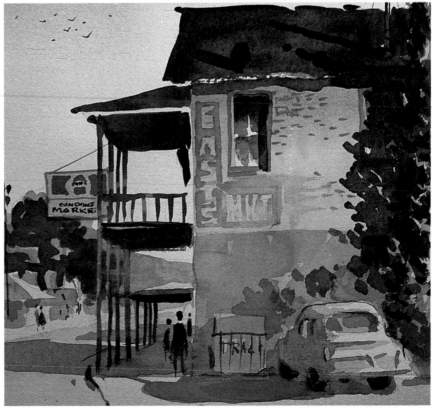

Detail of "Summer Rain": An example of paper with a porous, soft surface

This was done on 300-pound Strathmore Gemini paper. When I put the paint on, I had to keep adding more because it kept sinking into the surface. This kind of paper gives the painting a softer, ethereal look. It's like painting on a blotter.

Detail of "Jenny and Ethel": An example of paper with an extremely rough surface

This was done on 400-pound cold press J. Green paper. It has a rough tooth to it that allows the paint to stay on the surface. Notice the jagged rough edges that resulted from dragging the brush across the bumps on the paper.

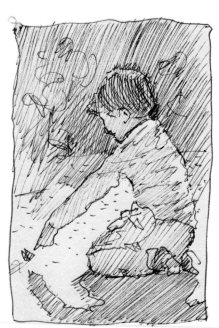

Sketch

ACHIEVING COLOR BALANCE

Composition sketch

This quick sketch helped me establish the basic composition before starting the painting.

Step 1.

A sheet of 300-pound Arches paper was washed with a pale mix of warm yellow—one part scarlet lake plus five parts new gamboge. While it was wet, I color-coded it with Winsor blue and scarlet lake. After it dried, I glazed the face and hands with flesh color made by mixing two parts new gamboge and one part scarlet lake. While this flesh color was wet, I touched the ear and cheekbone with middle-value scarlet lake and the shadow around jaw and neck with violet. Parts of the original warm yellow wash were left for edge light and reflected light on face, hands, hair, and costume.

Step 2.

I used scarlet lake and burnt sienna for the next big wash, leaving whites on hair, shirt, pants, and shoes. Around the figure and lawn I applied a mixture of two parts violet and one part Winsor green, using extra water for value changes. Salt was generously applied. The painting was allowed to dry thoroughly with no blow drying. Finally, I carefully scraped off the salt with my palette knife.

Step 1

Step 2

Step 3.

Using masking fluid, I painted hair, shirt highlights, spots, and highlights on sleeve and hand. Next, I masked the butterfly and each dandelion. When the fluid was dry, I put a pale green wash on the upper lawn. Next, I brushed in dark brownish green (two parts burnt sienna plus two parts Winsor green plus one part Winsor red). While this mixture was damp, I put in the flowers, using yellow, reds, and dark green—umber for stalks. Rich brown was used for trousers, blue for shoes.

After blow drying the picture, I took off the masking fluid and washed over the small dandelion shapes with rich new gamboge yellow, painted the butterfly with a yellow-scarlet lake mixture, and darkened the hair with burnt umber.

Then I glazed the whole shadowed part of the figure, including cast shadow, with a warm, grayed violet.

Finished painting

"Orange Butterfly" is an example of color balance in a painting. The major part of the watercolor is in shadow. The warm sunny backlighting contrasts effectively with the large, cool, blue and violet shadows that dominate the painting.

Upon close inspection, you can see grayed violet in the background and on foreground shadows. I glazed the same violet on shirt shadows as I did on the rest of the boy and grass.

The reddish-brown hair and flesh harmonize against the dark, grayed greenish-violet background. The bluish-violet shirt and shadows contrast with the grayed yellow dandelions.

To keep the background from being monotonous, I painted sienna and scarlet lake flowers into a semi-wet, grayed blue violet wash and accented the area with burnt umber stems and leaves.

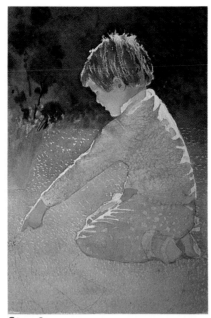

Step 3

"Orange Butterfly"
22" × 30" watercolor
Collection of the Artist

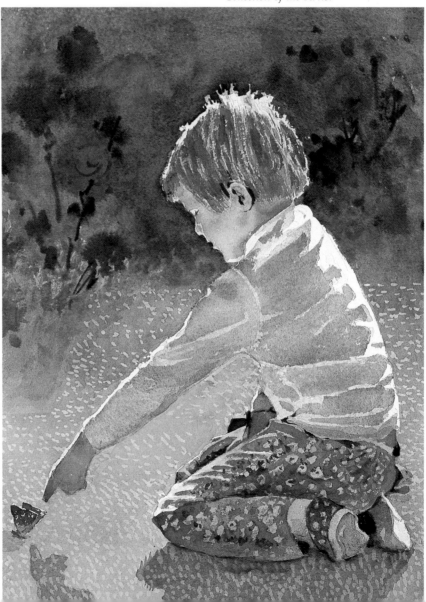

CLEANLINESS: KEY TO SUCCESS

I've been kidded by my students about my unwavering desire to keep my palette clean. There are sound, practical reasons for my fastidious habits.

I use a Pike palette that's pure white. If I want to see how my color mixture will look on watercolor paper, I need to keep the plastic surface clean. If it gets stained by colors, a little paint thinner on a piece of paper towel will shine it up. Don't use a lacquer base—it'll soften the plastic. After each color wash, I thoroughly clean the palette with towel and water. This may seem a bit much, but it's a small price to pay for what I get—*clean color, clean washes,* and *clean glazes.*

Keep your paint fresh, too. I dampen mine every few days—not every day. If there's new color left at day's end, and it's clean, I fill the module with water. By morning, the color is moist and workable.

Mud results from too many mixes—on palette or paper. Thoughtful planning will help you achieve bright, sparkling color that sings.

Design sketch

This sketch was a one-minute quickie done to arrive at the design and composition, including placement of the barn figures. It isn't what you'd call a finished sketch.

Finished painting

From the beginning of the toning wash through the color-coding and final clear glazes, cleanliness prevents the formation of mud, both on the palette and in your colors.

Here the sky was done in one wash, with red and blue dropped in. The foreground was also done in one wash with grays dropped in while wet. Calligraphic burnt umber accents were put in later.

The barn, trees, and weeds have two glazes, with burnt umber calligraphy. I left whites for light areas on the fence and rocks, then added clean color for the shadow side.

There is no mud color here. Planning and a minimum of glazes have kept the piece luminous. A clean palette kept mixes pure. Mud comes from inappropriate combinations of too many colors. Thoughtful mixing and clean application make color bright and clear.

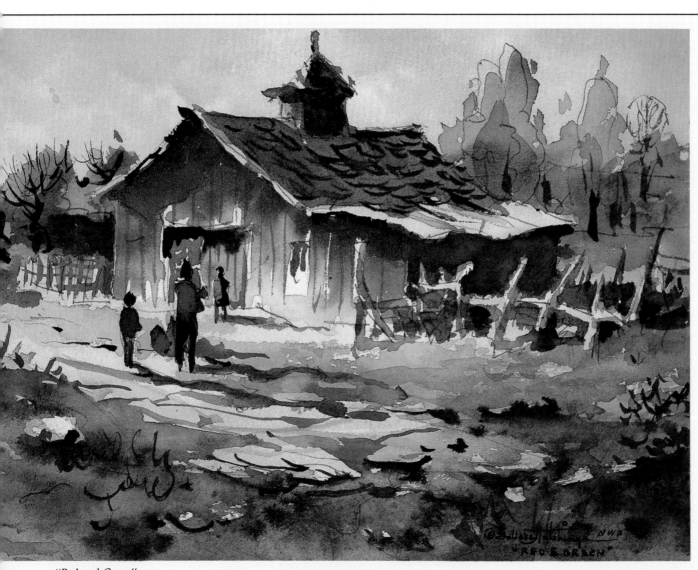

"Red and Green"
6½" × 8" watercolor,
140-pound Magnani Corona
Collection of the Artist

CHOOSING A COLOR SCHEME

Your choice of a color scheme depends on:

- Subject matter
- Center of interest
- Emotion involved
- Story told
- Time of day or night
- Season
- Occasion
- Mood you want to project

I paint with colors I can be most effective with—ones I like most. You need to mentally paint the picture before you even lay a brush on paper.

COLOR CONTINUITY

Color continuity is the proper distribution of color throughout the painting.

One of my heros, Hayward Veal, was an admirer of the French Impressionist Monet. Veal studied under a student of Monet and came away with his own impressionist style. His paintings sang with light and color. Up close, all one could see were clusters of thick color globs. A short distance away, the pieces took shape and literally vibrated. One of Veal's tricks was to point to any spot on a painting to see if the color scheme was exciting at that particular spot. He also aimed for continuation of color throughout the painting.

While my style is different, I try to distribute color so that at any given point, all the colors are present or close by. This procedure creates an underpainting of related color that helps to establish visual continuity. If you look closely at "Mark Twain's Cabin," you can pick out red, yellow, and blue spots of color glowing throughout the painting.

Continuity of color supports balance and harmony and lends emphasis to the design.

COLOR-CODING

Color-coding is the laying down of pale color areas in preparation for additions of color later on. It acts as a delicate, impressionistic testing pattern of color that actually previews my basic color scheme.

Corrections in value are often required. This is an ideal time to consider overall value structure and resolve the relationship between values in the sketch and color values in the painting. This is the time to delete, soften, strengthen, or change color harmony structure if need be.

Color continuity will be more assured if the painting is given an underpainting of primary color. Now is the time to lay down the toning wash and color underpainting. Color-coding suggests the use of special colors for specific areas, with all areas related through the wise distribution of delicate primary colors throughout.

"Hornitos": An example of color-coding

Color-coding is putting appropriate colors in appropriate areas while the paper's wet.

First I covered the entire paper with a pale yellow wash. While it was wet I dropped in spots of Winsor blue and scarlet lake red. While this was still wet, I brushed in appropriate color areas: yellow ochre mixed with grayed violet for some of the roofs and the hill in the background; thalo blue for the sky, rooftops, and shadows; yellow ochre and burnt sienna for the trees and buildings, and yellow ochre and Winsor green into foliage areas.

This created a pearly, impressionistic, preliminary painting that showed me: 1) my design, 2) my color harmony, 3) the beginning of my value patterns, and 4) the embryo of the emotion of the piece.

"Hornitos"
15" × 22" watercolor
Collection of Anita Schryver

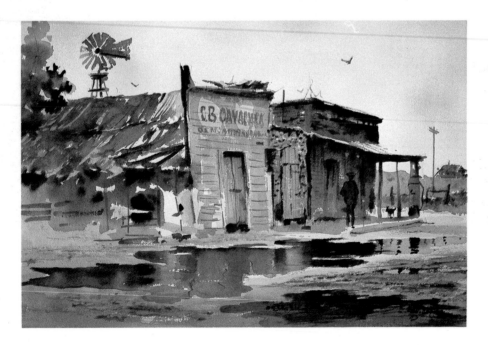

"Mark Twain's Cabin": An example of color continuity and color-coding

I had a hard time painting this because the wood was dull and old and uninteresting. So I started out with a light yellow (new gamboge—the only yellow I use) toning wash. While it was wet I dropped in a few spots of pale thalo blue and pale scarlet lake. While this background was still wet I color-coded each area of the painting with an appropriate color, i.e., yellow ochre and green for leaves and shrubs, grayed violet for distant trees and buildings, and earth colors (burnt umber, burnt sienna, and yellow ochre—that I allowed to blend) in the foreground and on the cabin and tree trunks. All this was done in delicate colors.

With color-coding I make a delicate impressionistic design to show what my basic color scheme will be. After it dries I put on deeper, darker colors. Then when that dries I put in the calligraphy, tree trunks, etc., for darker colors.

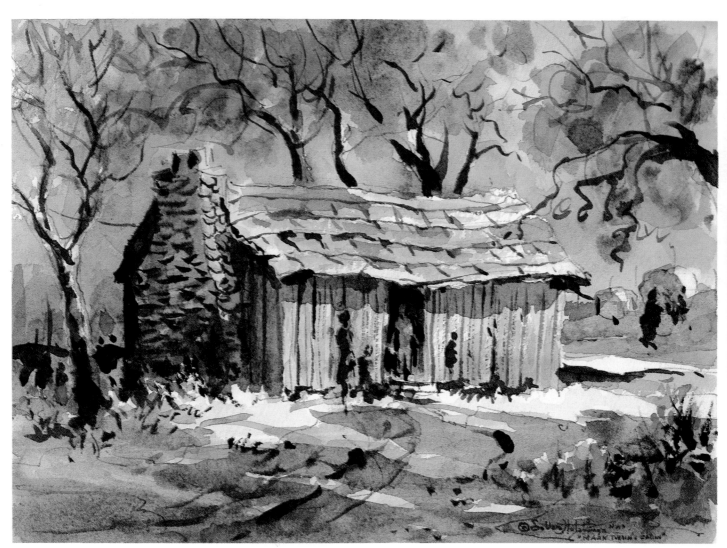

"Mark Twain's Cabin"
6½" × 8" watercolor,
140-pound Magnani Corona
Collection of the Artist

COLOR-MIXING PROCEDURES

Mixing on the palette

Prior to applying color to the paper, I prepare, mix, and evaluate it on my palette. Through trial and error, I've discovered that what I see on the palette will represent how the paint will look on the white paper. However, it will dry a bit lighter.

No place is more appropriate for experimentation than a clean, hard, white surface, like a plate, butcher's tray, or palette—I'm speaking now of palette mixing. This is the place and time to warm, cool, thin, thicken, gray, neutralize, or even wipe it all off and start new. A piece of scrap 100 percent rag paper is recommended for testing color.

Mixing on paper

This is a different ball game than palette mixing. It's exciting; I do it a lot. The technique can create bold and lovely surprises. There are several ways to mix on paper:

- Touch-in color into a wet wash or glaze.
- Drop in a complementary color in wet areas so that it makes new colors.
- Add warm colors to cool washes for balance.
- Glaze over dried washes to create new colors.
- Create graded washes by adding full-strength color to one edge or thinned color to the other side.

THE COLOR OF SHADOWS

Shadows seldom look dull and lifeless, and they should not be painted that way. Just because they are lower in value than the light-struck areas of your picture, they don't have to be gloomy. When you really look into shadows and allow your eyes to adjust to the lower levels of light, you'll see a lot more color than you'd expect.

Shadow areas deserve careful thought. In many ways shadows are the telltale evidence of an artist's ability to render his subject.

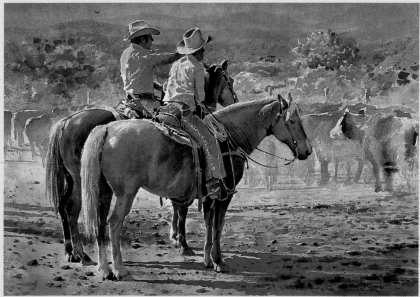

"Splitting the Herd": An example of the intensity of color in shadows

The shadows under the horses are darker and more intense in color because they are closer to the subject. As they extend outward from the horses more ground color shows through.

"Splitting the Herd"
27" × 36" watercolor
© Haddad Fine Arts, Inc.

HANDLING BRIGHT SUNLIGHT

Design and value sketch

This pen sketch suggested the basic design, a value structure, and the kind of scene that invited painting.

I kept my color values close to these black-and-white tones, although changes were permissible. For example, the tree, which is light in the sketch, became dark in the painting.

Step 1.

After drawing the scene, I covered the paper with a yellow wash. Into this wash, I color-coded the areas. I was especially concerned about the gate and shadows and leaving a lot of whites for further developments. At this point, I didn't know how bright I wanted my yellow oranges to be.

I brushed in grayed violets, Winsor blues, and permanent rose—all quite diluted.

Step 2.

The second stage consisted mostly of glazes over the dried color-coded areas. Because I used no masking, I painted around all whites, including limbs and lacy branches. Winsor green and burnt sienna, mixed, were used for grass and foliage. Grayed violet and bright violet were used in the dark area behind the car. I used yellow ochre for gate boards, adding grayed violet in certain darker areas.

Finished painting

By now I saw I needed more sunlight, so I brushed a warm yellow-orange (a mixture of two parts new gamboge with one part scarlet lake) onto the foreground, car door, roof, and other sunlit areas. The effect was like having the sun come out from behind a cloud.

A mixture of about one part French ultramarine blue and an

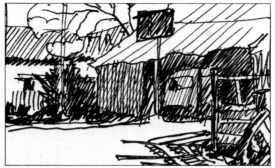

Design sketch

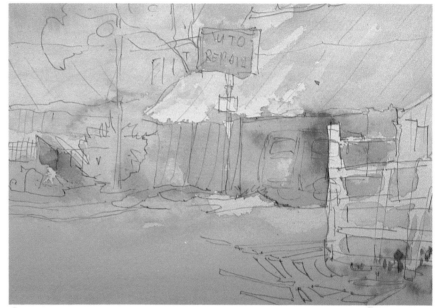

Step 1

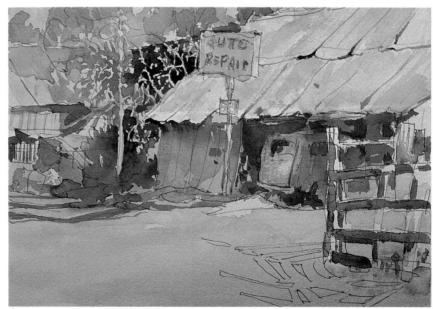

Step 2

equal amount of permanent rose was used in the foreground for the shadows cast on the road by the gate. The lighter shadow areas were made with the same mixture diluted with more water. The shadows in the left foreground were done with Winsor blue. The foliage was darkened by using Winsor green as a base. One part Winsor green plus two parts new gamboge created the yellowish green spots; one part Winsor green and two parts

burnt sienna made the warm brownish greens. I used one part new gamboge yellow, one part scarlet lake, and a touch of Winsor green for some color variety in the trees. For the shadows behind the garage, I made a violet from one part French ultramarine blue and one part permanent rose with just a touch of Winsor green.

The final pale, bright glazes of different reds, oranges, and violets were added to the roof, fore-

ground, fence, and auto. A few burnt umber accents were added to help make the light colors sing.

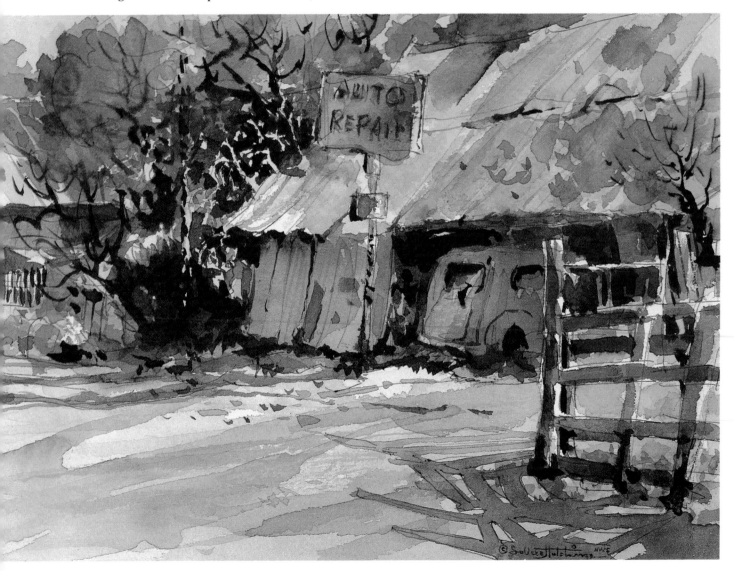

"The Sun Came Out"
6½" × 8" watercolor,
140-pound Magnani Corona
Collection of the Artist

COLOR HARMONIES

Theorists of color generally classify color harmonies into six basic categories based on the color wheel.

Monochromatic

This scheme is completely harmonious. Only one color is used, and variations of light and dark tones provide interest.

Analogous

An analogous color scheme uses three or four colors adjacent to one another on the color wheel. Example: red, red orange, orange, yellow orange.

Complementary

Opposites on the color wheel form a complementary color scheme. Examples: red and green, blue and orange, yellow and violet.

Double Complementary

Examples of a double-complementary scheme include: red violet and violet plus yellow green and green; blue green and blue plus red orange and orange.

Split Complementary

Two adjacent colors on the wheel plus the color opposite them make up a split-complementary scheme. Examples: red and orange plus blue green; violet and red plus yellow.

Triads

Any three colors equidistant around the color wheel form a triadic harmony. Example: red, yellow, and blue; violet, green, and orange; red violet, blue green, and yellow orange.

Warm against cool

My basic color schemes come from mixing the colors for my color wheel. I've discovered I can't bring color harmony to a climax without employing warm against cool. In fact, my philosophy of creating excitement, when all else fails, is to place warms against cools. It's surprising how effective this simple device can be, if I avoid muddy tones.

I prefer a type of double-complementary color scheme, putting emphasis on one of them as dominant with the other secondary. For example, in a red-green painting, I will have used violet-yellow or blue orange as a secondary harmony.

There are many examples of warm-cool harmony throughout this book. "The Pier" is a good example.

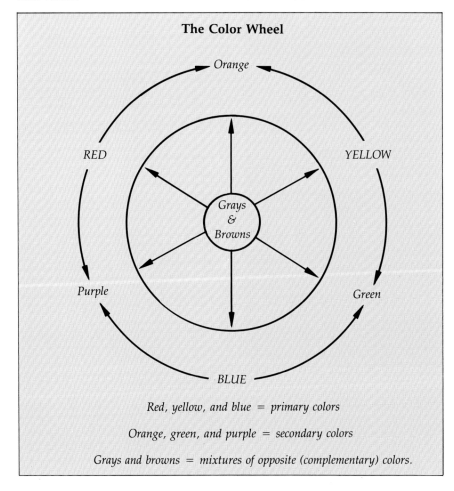

The Color Wheel

Orange

RED *YELLOW*

Grays & Browns

Purple *Green*

BLUE

Red, yellow, and blue = primary colors

Orange, green, and purple = secondary colors

Grays and browns = mixtures of opposite (complementary) colors.

Color's basic qualities
1. *Hue*—red, yellow, blue, etc.
2. *Value*—light or dark
3. *Intensity*—bright or dull
4. *Temperature*—warm or cool

47

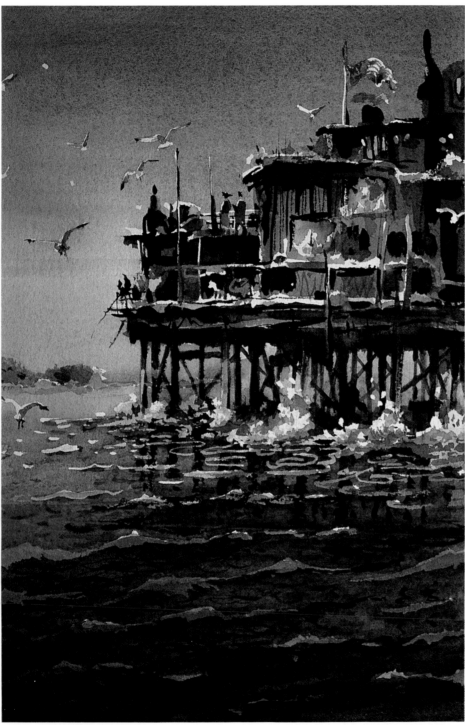

"The Pier"
22" × 30" watercolor,
300-pound Arches cold press
Collection of the Artist

"The Pier": An example of red-green and blue-orange harmony

In using this as an example of red-green and blue-orange harmony, I'm trying to show my use of warm against cool colors. In using red against green I have a warm and a cool; and with blue against orange I have a cool and a warm.

After I laid the sky color on I put some of it in the water so there's color harmony. The green in the water is also reflected in the sky and on the boards and windows on the pier. I've bounced my colors around a lot so there's color harmony throughout the painting.

The dark blues and greens and violets of the water are repeated up in the pier building, but in repeating them I made them brighter and lighter, and left white areas to make the areas vibrate more. I used more earth colors in the building, which made the pier more realistic.

I've painted some of the figures with the dark colors from the water. They're almost in silhouette and yet there is some color on them.

A DEMONSTRATION OF CLEAN, HARMONIOUS COLOR

Step 1.

I washed the surface of the paper with water and color-coded the areas while it was wet, using Winsor blue for sky and pale Winsor red for clouds, houses, and other areas. I dropped yellow into areas where sunshine fell. Violet was brushed into dark and shadowed areas. A few areas dried out and the color-coding was redone in dry brush. Sprinkling salt on the painting while it was wet created an interesting texture, especially in the foreground and on the road. No masking was used; I simply painted around poles and other light areas.

Step 2.

The second step in my paintings is the most challenging. That's when I'm most concerned with middle values that retain clean, harmonious colors. For "Back Street," I carefully scraped off the salt with my palette knife, then painted light violet into distant trees, side of the house, and shed. I added burnt umber for darker areas.

There are many greens in this painting. Here are three combinations: (1) one part Winsor green plus one part burnt sienna, (2) two parts Winsor green plus one part new gamboge, (3) two parts Winsor green plus one part burnt sienna.

A touch of scarlet lake will warm the mix, and a touch of Winsor blue will cool it. Violet will gray the hue. All of these mixes can be thinned.

The initial wash on the figures was done with Winsor red, middle value. A mix of one part violet and one part Winsor red painted the older person's dress and the dog. Burnt umber was used for dark areas.

Step 1

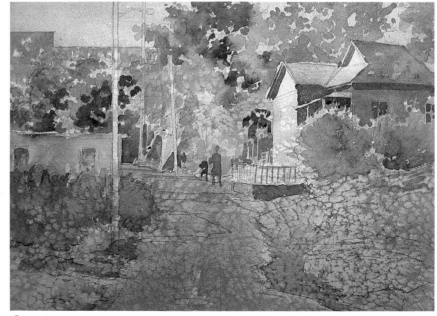

Step 2

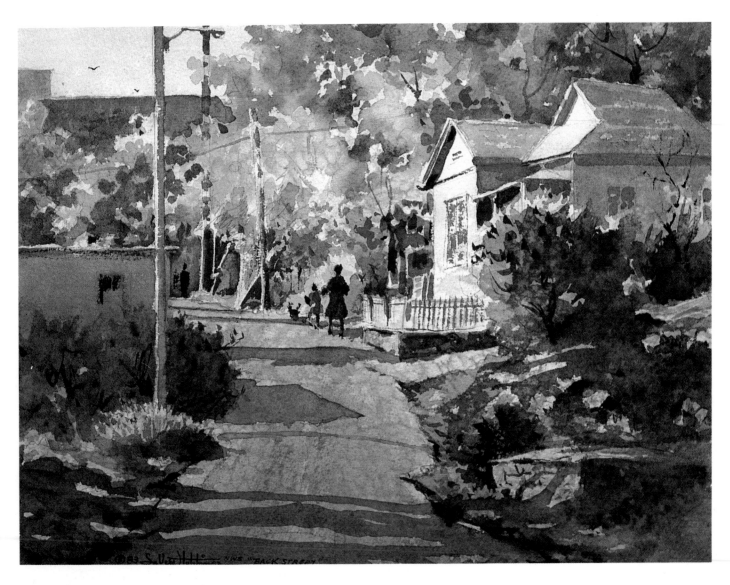

Finished painting

In the final step I worked to get more sunlight onto the road. I wet it with clear water, dabbed off the violet, and let it dry. Then I put on a middle-value wash of new gamboge yellow. Warm and cool greens were added to foliage and grass.

Next I mixed a warm violet, using three parts permanent rose with two parts French ultramarine blue, and glazed the shadows over all existing color. Notice that the shadows get warmer and grayer as they move up the road and onto house and background. This was accom-plished by thinning with water. The warm color underneath shows through a weaker glaze of violet.

"Back Street"
11" × 15" watercolor
300-pound Arches cold press
Collection of the Artist

PAINTING FROM A COLOR PHOTOGRAPH

Step 1.

A gas station doesn't seem like a likely topic for a painting, unless it goes under the heading of nostalgia. The challenge here was to see if I could paint it realistically and yet make it sing in some way.

When I looked at the photo, I decided I would paint the station as-is. I liked some of the shadows, but not all of them. However, the area above the station needed help.

Composition sketch
Step 2.

I made a quick pen sketch to establish the trees, light poles, sign, and shadow patterns.

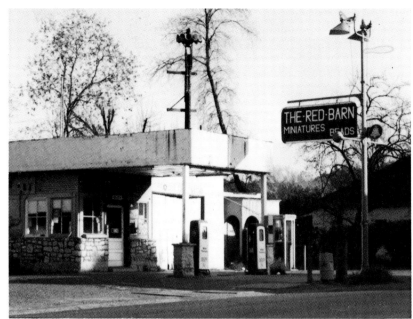

Step 1

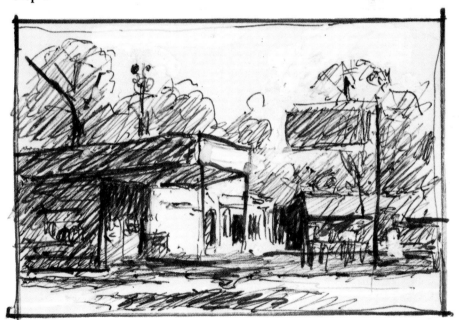

Step 2

51

Finished painting

I began with a new gamboge yellow wash, toned it with blue and red, and color-coded it for the major area colors in the painting. I followed the general color scheme in the photograph. However, my colors are brighter and stronger, giving the painting a happy, singing quality. The sky is more yellow, and the sky blues have been moved down into the blue roof and bounced around for color continuity, as have all the colors—reds, violets, greens.

The details could have been overdone, so I had to go easy, using a minimum of calligraphy, except in shadow areas, to suggest brick, windows, and doors. I purposely left out sign letters and identification to alleviate the commercial look.

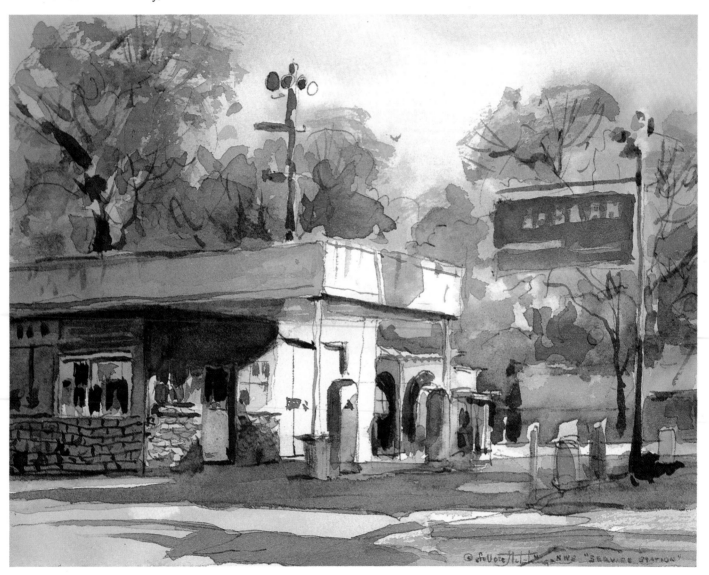

"Service Station"
6½" × 8" watercolor
140-pound Magnani Corona
Collection of the Artist

COLOR CRITIQUE

When I watch children paint, I'm excited by their directness. They paint what they think they see.

When grown-ups paint this way, I call it the blue-sky-green grass-red-house syndrome. Intellectually they know the sky is blue, the grass green, etc., so they paint that way without observing the colors as they really exist. An amateur won't be conscious of color harmony. He won't notice that values are missing. Experienced artists should have the know-how and skill to use color properly. When you critique a painting for color use, ask yourself:

- Is the color fresh and exciting?
- Is color continuity employed?
- Is warm color used against cool?
- Is a range of color values employed?
- Does the color fit the mood?
- Does the color fit the subject?
- Does the color scheme tell a story or make a statement?
- Are grays used effectively?
- Is the glazing an asset or liability?
- What colors should be changed?

If the mental checklist is on the plus side, the painting is usually okay. If it isn't, I try to correct it without ruining it.

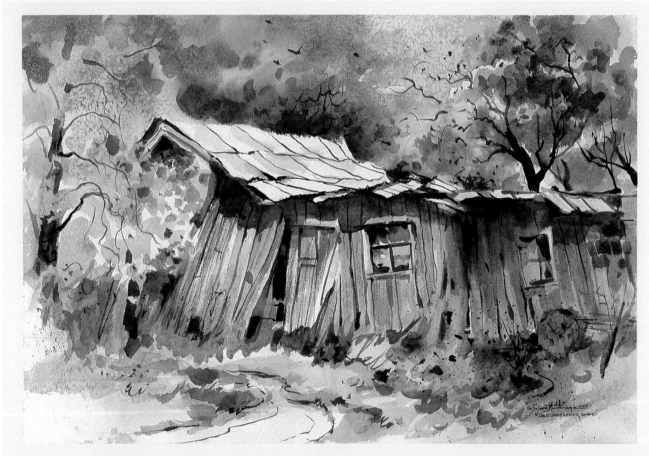

"Old Jamestown Shack": A color critique

I left light areas in this painting to create a feeling of luminosity because these old falling-down buildings have a tendency to look dark and gloomy—their colors don't sing naturally. After I got this feeling of luminosity I went back into it with burnt umber and did the calligraphy of the dark areas—tree trunks, boards, tin roof, etc.

My aim was for a loose flowing romantic feeling rather than a super-realist representation. The delicate trees and watery look of the building helped create the fluid movement in the painting. But my color choices—pale grayed violets and earth colors (used throughout the painting to give it continuity) were primarily what created the mood.

"Old Jamestown Shack"
17″ × 24″ watercolor,
300-pound T.R. (Three Rivers) cold press
Collection of Ray and Judy Esslinger

TEXTURE

One fun part of painting is texturing. Here I've demonstrated procedures that have proven useful to me in creating the kind of texture I like. Try them. They're all simple and can, when used in the right places, add both spice and a singing quality to your work.

Texture Demonstration
Figure 1.

I washed on cadmium red and let it dry. Next, I glazed on thinned Winsor red and let it dry. Then I glazed dark Winsor red crosses over the two reds. Burnt umber calligraphy was put on for accent.

Figure 2.

Using the side of a No. 12 red sable round brush, I dragged it over rough Arches paper for this effect. This dry-brush effect works in many places.

Figure 3.

This mix of French ultramarine blue and burnt sienna, when washed on and tilted, created a granular texture.

Figure 4.

A razor blade scraped off the high points of color—a useful effect when depicting weathered surfaces.

Figure 5.

Here we have the effect of masking. The design was painted in with liquid mask. I let it dry, then painted over it with blue. When the blue was dry, the mask was rubbed off, leaving the white paper showing through.

Figure 6.

This is the effect you get when

Figure 1

Figure 2

Figure 3

you paint over marks previously drawn with a white crayon. It's called a resist.

Figure 7.

These marks were made with my brush handle while the paint was wet.

Figure 8.

For each droplet, I dipped a brush *handle* into a bottle of rubbing alcohol. Then, after positioning it 3-5 inches above the wash, I tapped the handle with another one. This caused a droplet to land in the color. Repeating the process created a series of fascinating circular shapes.

Texture is important, but don't overdo it! To do so is like putting ice cream and candy on top of a rich dessert. The result is too much of a good thing, and texture assumes too much importance.

Figure 9.

After washes and glazes, touches of calligraphy added interest and suggested tree branches and other details.

Figure 4

Figure 5 **Figure 6** **Figure 7**

Figure 9

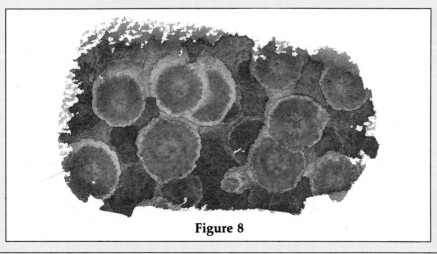

Figure 8

"Resting for awhile":
Painting surface textures

There's a great deal of descriptive calligraphy on the horse, rocky ground, weeds, and barn. Even the red plaid jacket is made more interesting with a textured finish. Upon close scrutiny, most of the texture is on the horse itself, including mane, tail, hair, and fetlocks. A wise artist learns to limit detailed texture to close-up objects to help give the painting a sense of depth. Usually a center of interest like the horse can have quite a bit of detail. When appropriate, I limit textural patterns on distant objects, like mountains and clouds, in order to show aerial perspective.

Texture is a finishing device, a way to delineate and describe. It's a relative thing. To one artist it's every hair, every shadow, every nuance. To another, it may be a few quick strokes of the brush, some salt, or other texturing devices. It may be a pattern of glazes, like those under the horse, in the foreground area.

I prefer to keep texturing relatively loose, even on close-up objects, to let air and light ebb and flow throughout. This way, I can suggest more luminosity and open up the color areas for freshness.

Texture isn't a substitute for sound design, but used wisely, with discretion, it can enhance and strengthen a painting, and help identify surfaces.

"Resting for Awhile"
22" × 30" watercolor,
400-pound J. Green cold press
Collection of the Artist

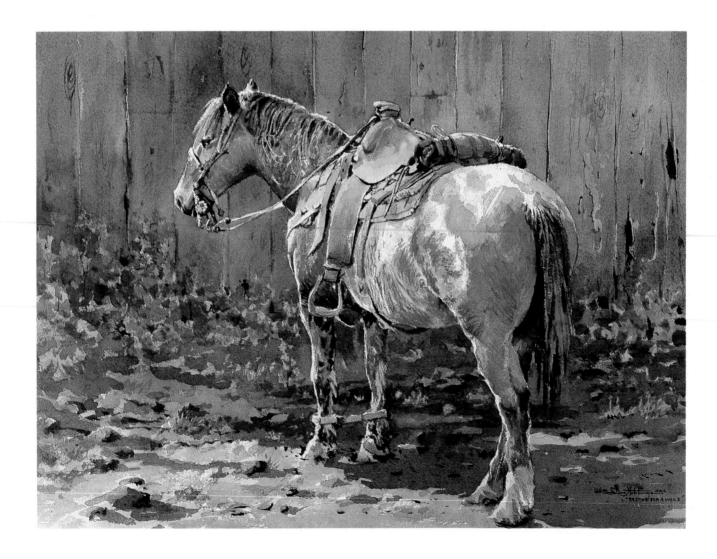

USING MASKING FLUID FOR TEXTURE ON A PORTRAIT

Step 1.

After careful drawing with pencil on 300-pound Arches cold press paper, I applied masking fluid to all of the *lightest* strands of hair. Next, I put highlights on the face at the nostril, nose, eye, cheek, and chin. Also, I highlighted the lower lip and just above the upper lip. Additional masking went onto hat and sweater highlights. I was especially careful to texture the hat by masking dots that would stay white.

A graded wash of three parts new gamboge yellow plus one part scarlet lake, well diluted, was washed onto the face and hair when the masking fluid was completely dry.

Step 2.

After the wash dried on her face, I glazed on darker tones of the same flesh mix produced by mixing new color—one part flesh tone to one part red violet with a touch of burnt umber. This mixture was diluted with water for shadows, with edges blended with clear water. The sweater was painted a grayed yellow with violet dropped in while wet. The bright cobalt violet was brushed on, full strength, and while it was wet, I dropped in some French ultramarine blue on the sweater and back of the hat.

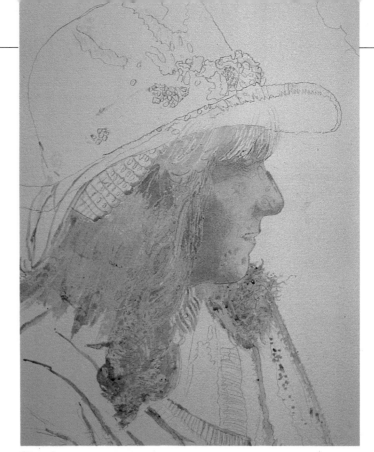

Step 1

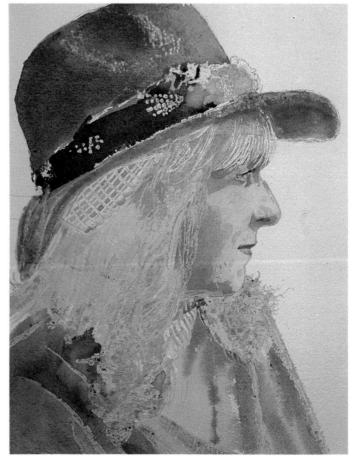

Step 2

57

Step 3.

Using all the colors just mentioned, I painted a varied background. Using a new gamboge wash in the whole area behind the figure, I dropped in cobalt violet near the top. The yellow grayed it. One part Winsor green mixed with one part burnt umber was charged into wet yellow behind the hat area for complementary harmony. More burnt umber and violet were separately dropped in the yellow near the shoulder, where they mixed and grays resulted. The whites in the background weren't masked. I simply painted around them. While the work was still wet, I sprinkled a few grains of salt on the background area for subtle texture. Quick dabs of cobalt violet in the background area helped color continuity.

Finished painting

It took more than four hours to finish the painting. I carefully brushed in burnt sienna for the hair and concentrated on the details—highlights and shadows. Eye, nose and mouth were shaded and accented with a pale grayed violet. Sweater and hat were carefully worked over to show subtle textural quality and gradation, with special attention given to the textural highlights on the hat. I devoted a lot of time to the hairnet, hatband, and feather.

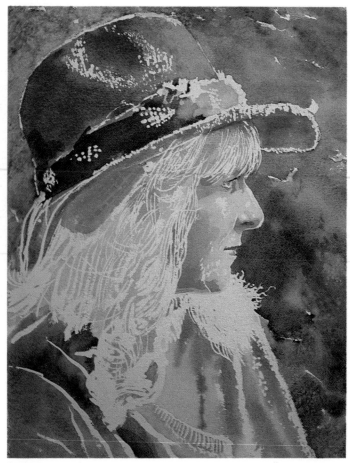

Step 3

"Lady in a Purple Hat"
15" × 22" watercolor
300-pound Arches cold press
Collection of Allen Lowrance

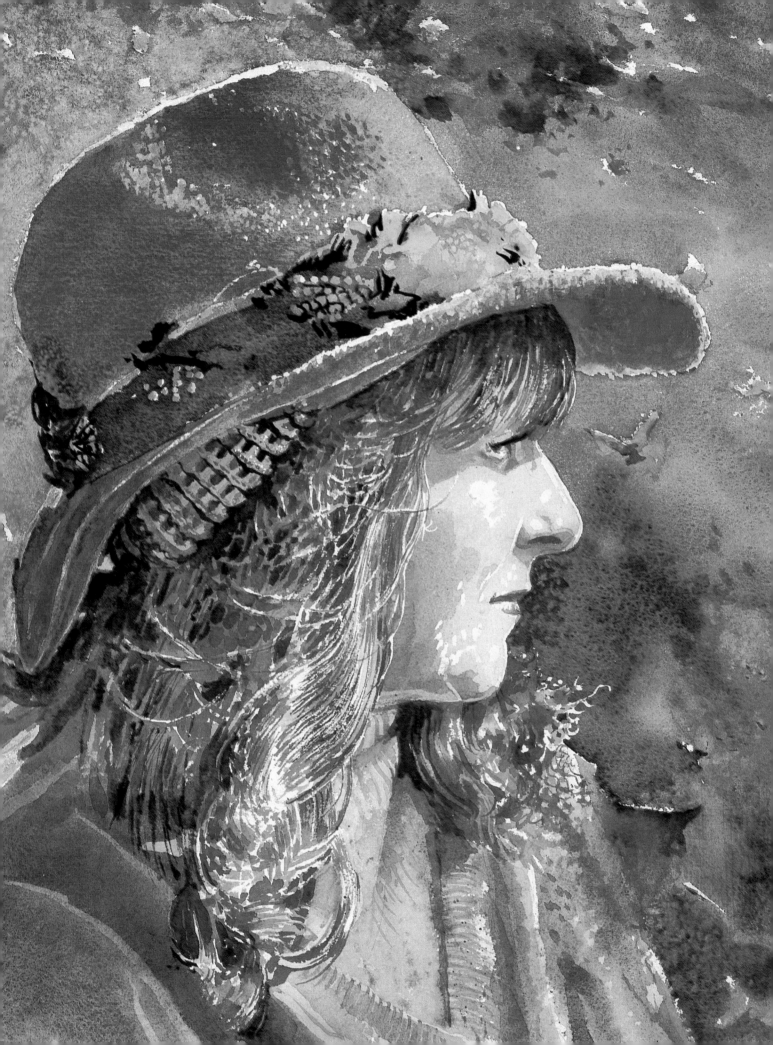

"Back Street": Texturing with salt

The painting titled "Back Street" demonstrates what grains of salt do when dropped into wet color. I'm not sure what actually takes place chemically, but some kind of a push-pull action goes on. The results are somewhat unpredictable snow-flake-like shapes. Imagination can turn the resulting texture into almost any kind of surface, such as tree bark, grass, or soil.

Salt can also help create surface design continuity, as you can see in the demonstration. This exercise was done on a piece of Arches cold-press paper.

While I often use salt, the major parts of my paintings are painted without it. Like all textural effects, salting should be used sparingly.

Beginning stage of "Back Street"
Finished painting on page 50

SALT TEXTURING IN A LANDSCAPE

I sketched this scene from my car. The light roofs of the old miners' shacks and patches of snow formed shapes that contrasted sharply against the darker oat fields and still darker oak trees on the hill. The greatest contrast of dark and light occurs between the walls of the shacks and the snow patches, forcing our attention to this center of interest.

Step 1.

I painted a yellow ochre wash around white areas, brushing in Winsor green and burnt sienna for undulations on the hillside. While the picture was still wet, I sprinkled table salt on the whole painting and let it dry. At this stage, the white buildings appeared as negative space.

Step 2.

I carefully brushed off all salt grains. Be sure they're gone. I've worn out sable brushes by brushing over rough salt passages. Then I mixed one part Winsor green and one part burnt sienna with a touch of alizarin crimson for the tree color. The sunstruck side was softened with water while it was wet.

Step 1

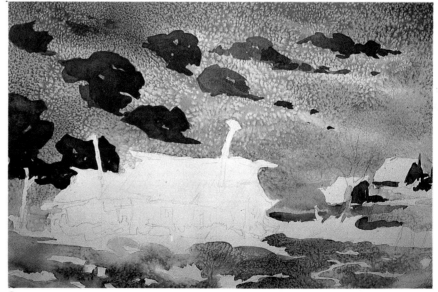

Step 2

Finished painting

Shadow color was made from one part alizarin crimson and two parts French ultramarine blue. There's a lot of warm yellowish brown in this picture—so much, in fact, that it could become monotonous. To avoid this, I mixed Winsor blue into the siennas and umbers in the shack walls. I also added a pale Winsor blue glaze for the snow, shadows, roofs, and other white areas. This created a warm-against-cool color scheme. I also used pale violets, yellows and cool greens on the roofs. The overall effect achieved the mood I had hoped for.

"Old House at Volcano"
15" × 22" watercolor,
300-pound Arches cold press
Collection of Dr. and Mrs. Denver Perkins

TEXTURING WITH BRUSH AND PAINT

Photograph

At a recent workshop, my students gathered around as I made rough sketches of this less than inspiring street scene.

I liked the view, but the corner of the building seemed to divide the picture in half. The challenge was to come up with a design that would tie the scene together and make the big flat wall a little more interesting.

Design sketch
Step 1.

Using a simple line drawing, I worked out a design. The solution was the use of shadows and directional movement to tie the two corners together. As morning went by, foreground shadows crept further into the scene, turning the foreground into a dark shape that created a feeling of depth.

As I began the sketch, I knew it must suggest the luminosity I wanted the painting to have, so I was careful with values, along with balance, movement, and light and shadows. Without people, the scene looked stark, so I borrowed some folks from across the street.

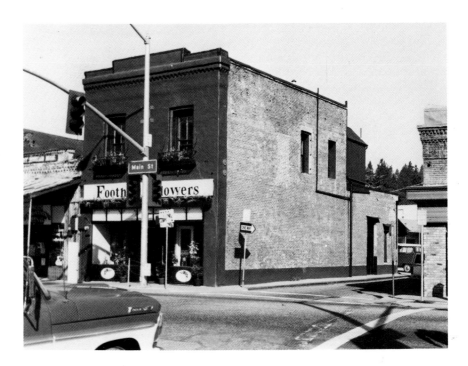

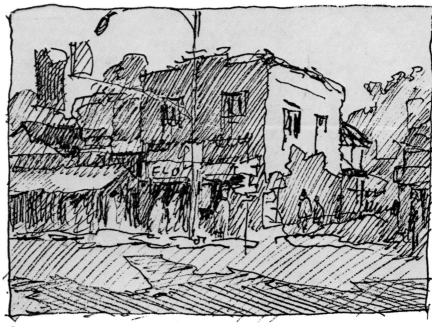

Step 1

Step 2.

Sunlight and shadow are two important ingredients that can help a watercolor sing. So my initial toning wash was a sunshine color—new gamboge yellow. While the painting was wet, I color-coded it, using scarlet lake on buildings, Winsor blue on sky and foreground, violet for some foreground areas, and burnt sienna touched into all areas. The clouds were created by painting around them with Winsor blue.

Here's something to consider: with a yellow wash already down, each color dropped in is affected by yellow. The harshness of pure color is neutralized. All colors become related because they have yellow in them.

At first the sunlit foreground was too dark, but when it dried it lightened. The finished shadows also made it look light.

No masking or salt were used. All whites were saved. All texturing was created with a brush and the action of the paint on the rough surface of the paper.

Step 3.

Middle values were next. I mixed violet and blue violet for distant trees and dropped Winsor green into the lower part of these tree masses. Two things happened: the cool violets created distance, and the warm green against blues and violets created color harmony.

I glazed a reddish brown on the dark side of the flower shop, using one part burnt sienna, one part scarlet lake, with Winsor green dropped into it to neutralize it.

Mixtures of two parts violet plus one part burnt sienna made nice, luminous darks for roofs and the storefront next door.

Step 2

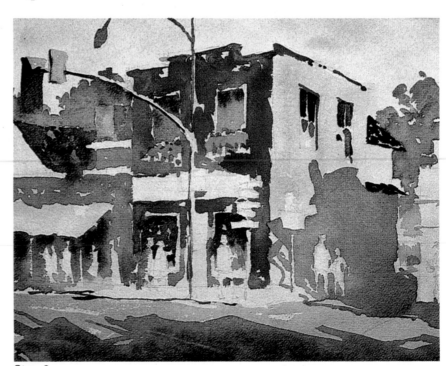

Step 3

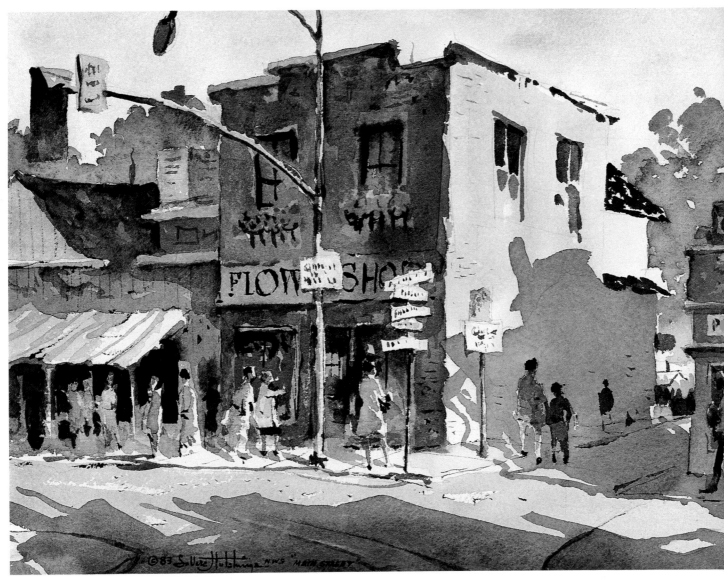

Finished painting

Next I brushed in the cast shadow color in the foreground and on the right side of the main building. It was a mix of French ultramarine blue with a little permanent rose. I also used this mix for the windows.

Notice I painted around white shapes to form people, signs, and accents.

The finishing procedure was important to the painting's success. It included the adjustment of values, attention to edges, and the careful rendering of figures. I worked for color continuity, good design, and balance.

"Main Street"
15" × 22" watercolor,
300-pound Arches cold press
Collection of the Artist

ACHIEVING TEXTURE WITH GLAZING

Three-value design sketch
Step 1.

This pen-and-ink sketch was done at the scene. The design is basically what I saw, although I did evolve my own color scheme.

I was intrigued by the way the road carried the eye into the painting. In order to make it interesting, I had to create an abstract design in the painting which began with a three-value design. One of the things I had to do was make the road and some of the sunlight on the trees and building the lightest value, and the hill in the back and some of the shadows the middle value.

The darkest value is the shadowed area on the road and trees. It's supposed to be a three-value sketch, but actually it has about five values.

I used white areas as negative space to begin with and then put middle values in to get the design. Next I added my darkest values for details. At that point the negative space became the most important area. The most important areas of the finished painting are the sunlit areas.

Step 1

Step 2.

After putting a pale yellow toning wash over the entire painting, I dropped in Winsor blue and scarlet lake. When the paint was dry, I painted a hard-edged bluish violet skyline in the distance and rewet everything below it with clear water. Next I color-coded the areas—pale grayed green trees, pale grayed violet road, shadows, and some distant trees. The eye-catching red-orange explosion resulted from the action of salt on big wet areas of scarlet lake, yellow, and burnt sienna. It looks pretty wild—but exciting!

Step 2

"A Country Stroll"
22" × 30" watercolor,
300-pound Arches cold press
Collection of the Artist

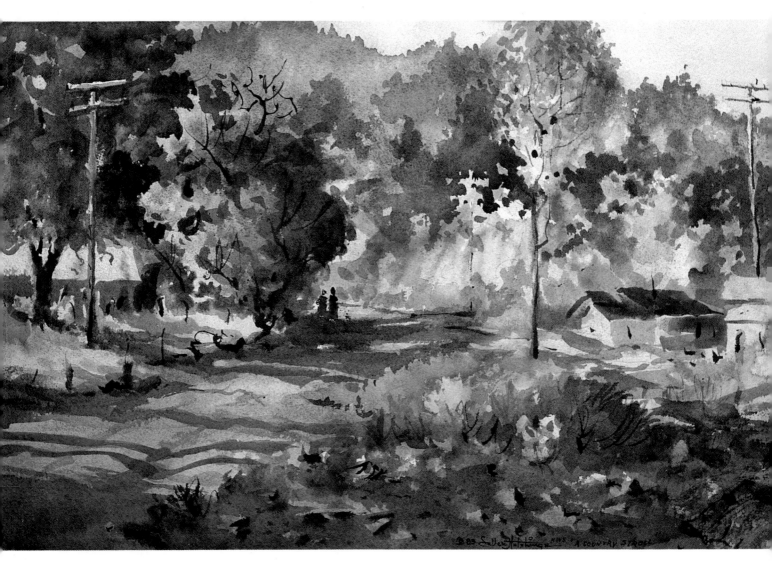

Finished painting

The delicate but colorful stage was now set for a bright, clear application of glazes. Notice the following:

• *The colorful, oval-shaped tree at left center.* It popped out and really vibrated with color. The left side of the tree is light against dark background, the right side dark against light. I tried to save the scarlet lake. Most of it shows, either on the surface or up through the color glazed over it.

• *The lacy, luminous row of trees behind the house coming forward through the use of dark against light and cool behind warm.*

Grayed violet, mixed with permanent rose and French ultramarine blue, is great for glazing and shadow patterns. I used it on the pavement, bushes, trees, and rocks.

MOOD AND LIGHTING

CAPTURING MOOD (JOYFUL)

"Early Summer"

I've always loved early morning and the feeling of luminosity the sun creates at that time of day. How I created the mood: I made some of the details of the painting appear to be washed out by strong sunlight. In shadow areas I let more detail show up.

There's a warm joyful glow to this painting. The feeling of sunlight evokes the mood. The early morning sun hitting the house creates a feeling of awakening. The flowers, tree, and fresh-looking earth evoke the smell of new things growing.

"Early Summer"
15" × 22" watercolor,
140-pound Arches cold press
Courtesy of Tonian Hohberg Collection

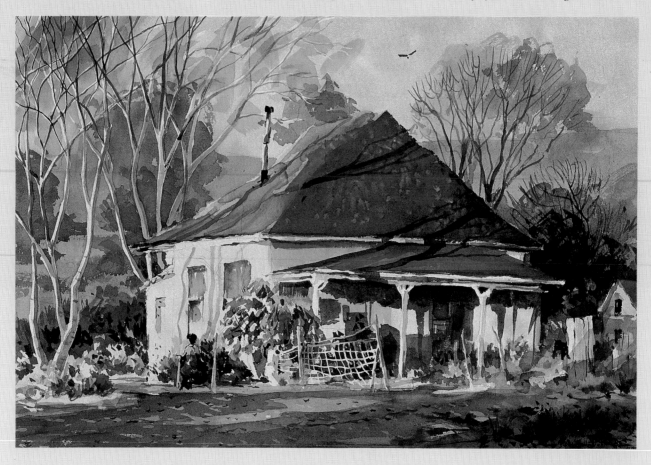

MOOD

The mood of a scene identifies what's really going on. The sea may be beautiful, blue, and sparkling one minute, but the mood changes when a storm turns it black and turbulent.

Many things affect the mood of a subject: rain, wind, the season, time of day, and light, to name a few.

One of the obvious ways to create mood is with color. A roomful of bright colors such as pink, orange, and yellow, cheers us up. And we're all aware of the sobering—even depressing—effect of being surrounded by the dark somber tones of black, purple, blue, or gray.

The mood of the artist is also important. My level of creativity is affected by my mood. I ask myself: Do I really want to paint, or am I just doing it out of habit? Does my subject really excite me?

"Mother Lode Scene"
11" × 15" watercolor,
140-pound Arches cold press
Collection of the Artist

CAPTURING MOOD (SOMBER)

"Mother Lode Scene"

It's the same area of the country, the same kind of trees, but the mood has changed to a somber, oppressive one.

How I used lighting to achieve mood: This scene has toplighting. Toplight paintings—rainy days and snow scenes where the sky is gray and light filters down—are usually moody.

How I used values to achieve mood: I lowered the key of the painting—I used few light values.

I used a lot of middle value areas such as the big washes on the clouds, and a lot of dark areas such as the tree masses and weed and road accents.

How I used color to achieve mood: I used oppressive colors. Heavy, blue-gray clouds are oppressive.

69

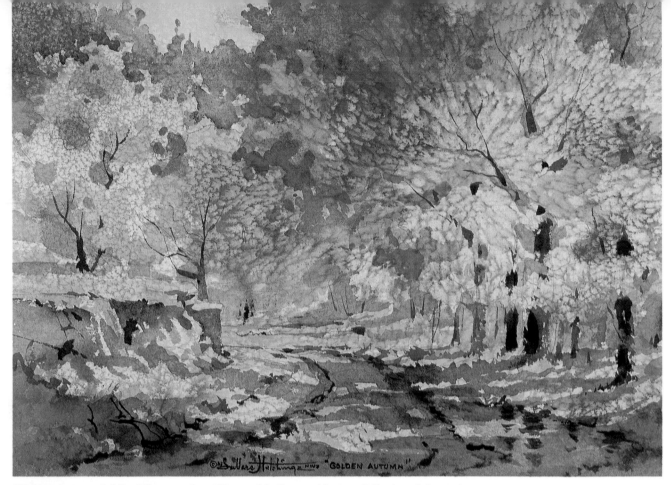

"Golden Autumn," 14" × 22" watercolor, 400-pound J. Green cold press, Collection of the Artist

HOW TO EVOKE THE MOOD OF A SEASON

"Golden Autumn"

In order to create a painting that suggests a season (in this case, autumn), an artist needs to consider a number of things—the kind of foliage, the kind of rocks, the color of the landscape, whether or not there's water. In fall there are many colors on the trees, mostly brilliant oranges, yellows, and reds. The areas around the trees are beginning to be covered with fallen leaves which reflect the colors in the trees.

When painting a seasonal painting one also needs to remember the influence of the sky. A blue sky reflects in the puddles. If the sky were gray and overcast it would take away the brilliance of the colors—the sparkle of sun on the colors.

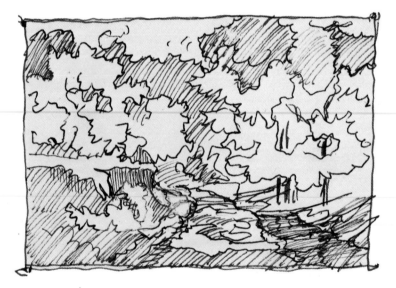

Basic value sketch
Step 1.

I began with a pen sketch done on the site. It seemed to have good values and lots of potential. Back in my studio, working from memory, I had to improvise color and details.

70

Step 2.

I started by covering the paper with a flat, pale yellow wash. While this was wet, I color-coded the areas—Winsor blue for the sky and puddles on the road, bright yellow for some of the leaf areas, and bright orange for the rest. The orange is a mixture of new gamboge yellow and scarlet lake.

Next, I shook salt over the whole picture and let it dry. As it dried, the salt absorbing the water created hundreds of leaves and an interesting texture. I don't use a blow drier for salted areas—it's better to let them air-dry.

I had to be careful with each tree. I didn't want to lose the design in my sketch, nor did I want to have hard edges. Some edges needed to be "lost" (blended into the background). One of the methods I used was to create shapes with delicate, grayed color. I did this on a trial basis. If I didn't like what resulted, I could easily remove it with tissues.

Step 3.

After the painting dried, I scraped off the salt with a palette knife. Next I put in the shapes of distant trees with ultramarine blue, gradually making this color darker as the trees come closer. Then I painted a thin wash of warm violet (a mixture of ultramarine blue and permanent rose) around the shapes of the yellow and orange foliage. Note that the blue and violet are darker than the orange and yellow.

I carefully put in the dark shadow shapes of the ledge at the left—using grayed violet for the rocks as well as the tree trunks and shadows they cast over the grass and road. The darker tones in the road ruts and rocks were made with a mixture of burnt umber and violet. The darkest accents in the rocks, ruts, bark, and branches were done with burnt umber.

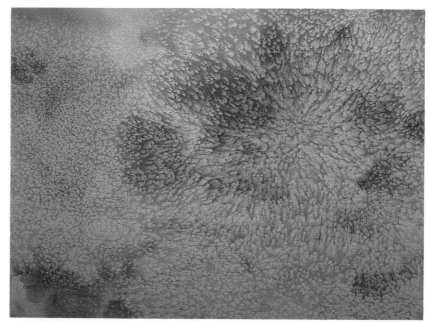

Step 2

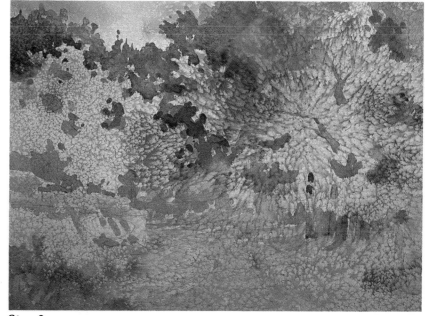

Step 3

EDGES

Edges are borders around space, color areas, shapes, masses, value areas, or parts of these areas. There has to be contrast in value, color, line, or a combination of these.

The more complex the painting, the more important the edges. You can get lost in a forest of them. The solution is to make them so interesting that the viewer will overlook any confusion.

As you paint, think: soft-hard, warm-cool, dark-light, and lost-found.

Edges tell the world a lot about you as an artist. They are something like handwriting: a person's qualities, frailties, attitudes, etc. show up.

To create excitement in edges, execute them with care. Caress them, treat them with tenderness.

Figure 1.
Hard edges predominate here, even though the background blends into right side and bottom. This is an example of lost and found edges, as the eye follows around the perimeter of the square. This texture is done with the side of a flat brush.

Figure 2.
Hard edges again predominate, but softening and blending into the background as water is added. At the top you can see lost and found shapes, like objects in a fog. The edges are soft and subtle, but still recognizable.

Figure 3.
The top edge is completely lost by adding more and more water, until it's clear. Even so, the three remaining sides are fairly hard edged, but still have interesting texture or roughness.

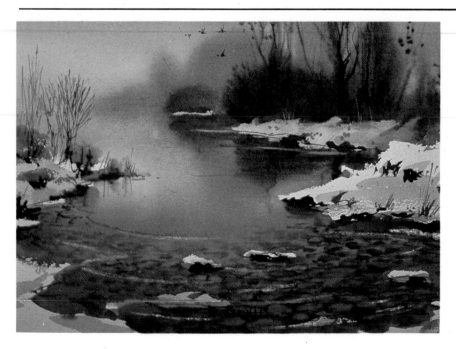

"Winter along the Tuolumne"
Before I put any paint on the paper, I took a white wax crayon (white so it wouldn't show) and with easy strokes masked highlights on the water in the foreground. These wax lines resisted color put over them and when dry appeared as white highlights.

In the background, I used the same kind of soft, foggy edges you see on the top side of figure 2. I mixed delicate grayed violet and touched it onto the wet bluish sky.

Some of the accents were done while the background was damp. The more the background dried the harder the edges became.

"Winter Along the Tuolumne"
15" × 22" watercolor
Collection of the Artist

"Anne Elizabeth":
"Lost and found" edges

Edges throughout this painting are "lost and found," which means they appear, then bleed into the background, then reappear. Notice how the edge of Anne Elizabeth's chin is indefinite—it fuses with the shadow on the dress. The point of her nose is a strong contrast with the background; then the bridge of her nose fuses with the background. The lens in her glasses is a strong contrast with the background at one point; then it's the same value as the background. And so on: the same technique can be seen in the hair and throughout the painting.

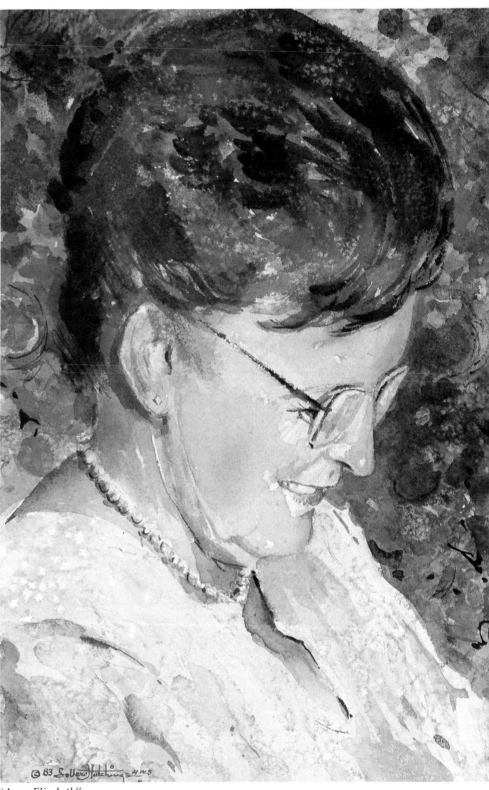

"Anne Elizabeth"
11" × 14" watercolor,
140-pound Whatman cold press
Collection of the Artist

LIGHT AND SHADOW

Light and shadow are important to artists. The ability to make shadows glow and vibrate is an asset. I remind myself each time I paint a shadow that it's really a passage of color—either a wash or a glaze—that is enhanced both by what's underneath and by what's on top of it.

On the following pages we'll consider some common lighting problems. Examples will show how I handled a variety of lighting conditions.

THE COLOR OF SUNLIGHT

Smoke, moisture, dust, and pollutants are present in our atmosphere. When sunlight passes through these substances, the emerging rays tint the clouds and landscapes with reds, oranges, and yellows. The flatter the sun's angle, the more atmosphere the rays pass through, and the deeper the resulting colors. This is why sunrises and sunsets are so colorful and dramatic and why clouds and landscapes have softer shadows in early morning and evening.

The time of day the sun least affects the color of objects is from 10 a.m. to 3 p.m., when the sun passes through the least amount of atmosphere. The result shows up as an off-white light that tends toward pale yellow.

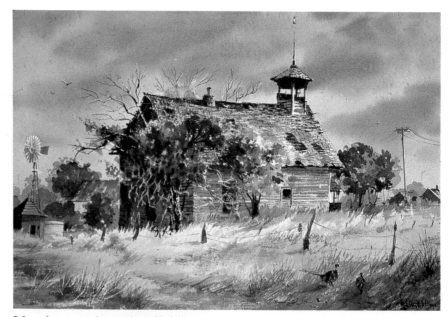

Morning sun (morning light)

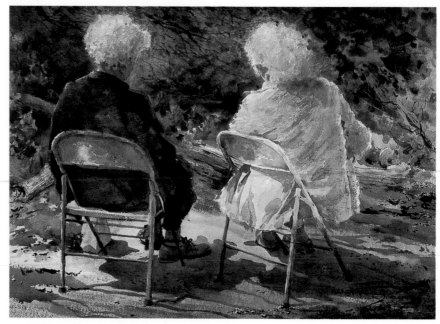

Middle of the day sun

74

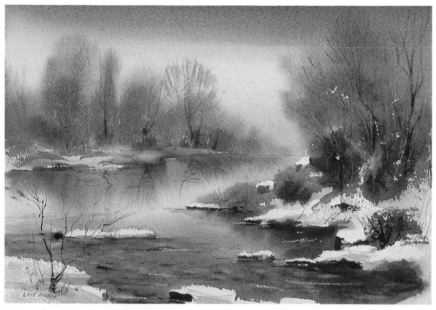

Late afternoon sun (early evening light)

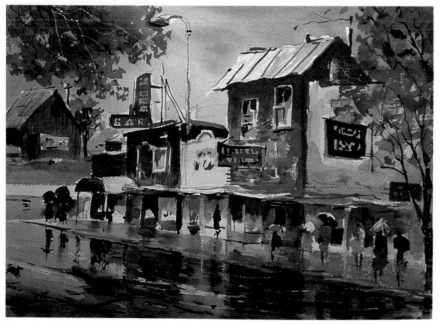

Top light through clouds

Examples of paintings with different kinds of sunlight:

Morning sun (morning light)

"Old School at Milton," top left.

"Main Street," page 65.

"Old Family Home," page 79.

"Early Summer," page 68.

Middle of the day sun

"The Sun Came Out," page 46.

"Back Street," page 50.

"Jenny and Ethel," bottom left and page 83.

"Holiday in Mendocino," page 114.

Late afternoon sun (early evening light)

"Green Ice," page 112.

"Rhapsody," page 31.

"Late March," top right and page 111.

Top light through clouds

" 'M' Street, Merced," bottom right and page 101.

"Old House in the Rain," page 19.

"A Wet Day," page 98.

"Hornitos," page 93.

"Snow in Jamestown," page 109.

"Tuolumne Winter," page 107.

"Churches in the Rain," page 103.

"Holiday"
14" × 22" watercolor,
300-pound Arches cold press
Collection of the Artist

"Holiday": An example of morning sunlight

From mid-morning on everything's a little more washed out than it is in late afternoon, when the light is warmer and more colorful.

Leaving excessive color off areas where the sun hits and putting more color in shadows suggests strong morning sunlight because it washes out the color in big light areas like the beach and sky. And it allows the artist to put a lot of colors in the shadows, particularly up close.

After drawing the design onto 300-pound cold press Arches paper, I used a liquid masking agent on figures, water highlights, trunks and foliage (in selected areas), and parts of the waves.

Using pale new gamboge yellow, I covered the entire paper surface, then color-coded each area—Winsor blue and scarlet lake for sky and water; Winsor green, burnt sienna, and yellow for foliage and bushes, and pale neutral orange for sand. I tried to put warm against cool in each area.

Glazing each area, using middle values, created the beginning of form. Again, I worked for warm against cool.

After the painting was dry and the rubbery masking removed, I put in the grayed lavender shadows, colored costumes, and burnt umber accents. A Winsor blue glaze across the bottom formed a base for the picture. The eye moves past this dark foreground strip to the center of interest.

"Yellow House at Valley Springs": Using shadows to create realism

Shadow is the glaze of color over an existing color. The existing color will affect that glaze. In "Yellow House at Valley Springs" I had already painted the house yellow, and I wanted to use a shadow that would look real. So I took a complementary color to yellow, which was violet, and thinning it to a middle value I added a touch of burnt umber to gray it.

Using as big a brush as possible, I loaded the brush with shadow color and made only one pass over the shadow area, without brushing over it again.

The yellow shows through the violet glaze, creating the impression of a lifelike shadow. Also, by using grayed violet on roofs and shrubbery, I got the same effect in these areas.

"Yellow House at Valley Springs"
11" × 15" watercolor,
140-pound Arches cold press
Collection of Mr. and Mrs. Nick LaVecchia

Step 1

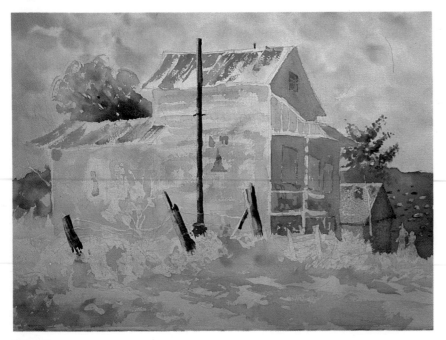

Step 2

HOW TO MAKE YOUR SHADOWS LUMINOUS

Basic value sketch
Step 1.

This quick sketch helped determine basic values of the painting.
Step 2.

Shadows should compliment a background, not hide it. In this painting I lightly sketched the area for the shadow. Then I mixed a puddle of shadow color—grayed violet—using half French ultramarine blue and half permanent rose. To gray it I added a touch of burnt umber. To achieve luminosity in the shadow I added a touch of yellow ochre. This also made it harmonious with the background.
Finished painting

Using the biggest brush I could (a 1" flat brush) and keeping my paper flat so I didn't get any running, I quickly brushed on shadow areas. While they were still wet, I mixed violet and burnt umber 50/50 and brushed this color under the eaves into wet shadow wash. This created a graded wash.

While the wash was wet I tipped my paper back and forth and let the darker wash under the eaves blend into the first wash. This created luminosity.

To achieve luminosity in shadows, there are two things you need to be sure you DON'T do: 1) keep reworking or going over a passage of color, and 2) Mix too many colors together either on the paper or the palette.

Either of these will make your painting muddy. I would rather underpaint than overpaint.

"Old Family Home"
22" × 30" watercolor,
300-pound Arches cold press
Collection of the Artist

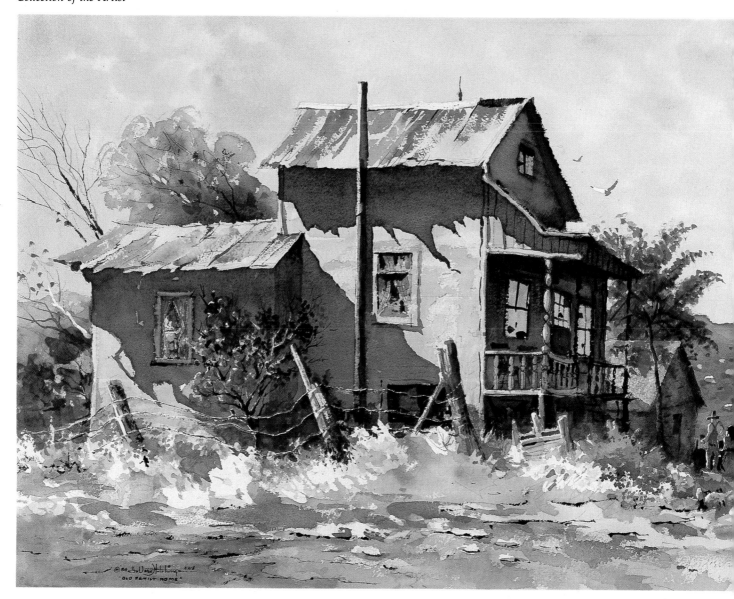

"Shady Lane"
11″ × 15″ watercolor,
300-pound Arches cold press
Collection of the Artist

DIFFUSED LIGHTING

Design sketch
Step 1.

This sketch is an abstract design showing eye movement throughout the painting. I did it so I could plan for the big tree masses being alive rather than just blobs of color.

In essence, these are directional lines which tie the painting together.

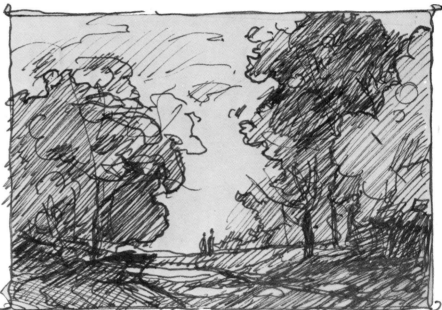

Value sketch
Step 2.

This simple drawing was done to determine areas of light, medium, and dark values.

Finished painting

Diffused light in this painting is caused by the strong slanting sun rays coming through the big masses of trees onto the horizontal planes of country road. Some areas of the trees are so dense they allow little or no light to come through. Only about half of the light has made it through the trees, resulting in diffused light.

Sunstruck areas on the road result from strong sunlight shining through sky holes in the trees.

OVERHEAD LIGHTING

Step 1.

This painting has involved some trial and error.

To begin work on "Jenny and Ethel," I tub-soaked a full sheet of 400-pound cold press paper and stretched it on a three-quarter-inch plywood support, stapling around the edge. I brushed a medium yellow wash onto the entire surface and color-coded the top half. The wet surface diluted the yellow, which faded to a delicate tint when dry. The color-coding was done with permanent rose, violet, Winsor green and burnt sienna. Salt was sprinkled on. I let the paint dry thoroughly before scraping off excess salt.

Step 2.

I continued on with glazes on the already yellow chairs, using three parts burnt sienna plus one part burnt umber, thinned. After this dried, I began modeling the chair parts, adding glazes of three parts violet plus one part burnt sienna for shadows and texture. The light coat, already yellow, received a burnt sienna glaze on the left, and on the right, a shadow glaze that blended from pale Winsor blue to violet. Reflected light caused some lightening in shadow areas.

Flesh tones were a mix of one part scarlet lake and one part new gamboge yellow. Additional scarlet lake was dropped into the wet wash. When dry, a shadow on the back of the neck resulted from a mix of one part violet and two parts scarlet lake. Highlights came from the original yellow wash.

The darkest coat is a reddish burnt umber. Many colors were used. The initial wash was a rich mixture of one part burnt sienna plus three parts violet. While it was wet, I dropped in areas of pure burnt sienna, pure perma-

Step 1

Step 2

nent rose, and pure French ultramarine blue. The surface granulated nicely, creating a texture. A violet shadow gave a three-dimensional look.

Everything looked washed out and pale. So I laid on a new gamboge glaze over *everything* with a 1½-inch flat brush. With this new, sunny look, my excitement grew. I carefully brushed on glazes—the shadow patterns in the foreground, a combination of violets and Winsor blues. The light-value Winsor blue wash was put onto the shadow patterns first and dried. Next, warm glazes of violet—one part French ultramarine blue plus one part

permanent rose—were laid on top of the blue: I wiped out a few spots for color variation, warm against cool. In areas under chairs, reflected light created warmer violet, so I dropped in a little extra permanent rose.

Finished painting

The backdrop resembles a tapestry. It's basically a warm gray, created from hundreds of color spots. I purposely lightened areas behind heads for a halo effect and darkened others for distance.

Burnt sienna glazes with burnt umber accents were used for texturing with the help of grayed violet mixed from violet plus a touch of burnt umber.

Notice the scumbling and lost and found edges throughout the picture. The final suggestion of texture on the coats, hair, heads, chairs, and foreground, completed the painting.

"Jenny and Ethel"
22″ × 30″ watercolor,
400-pound J. Green cold press
Courtesy of Tonian Hohberg Collection

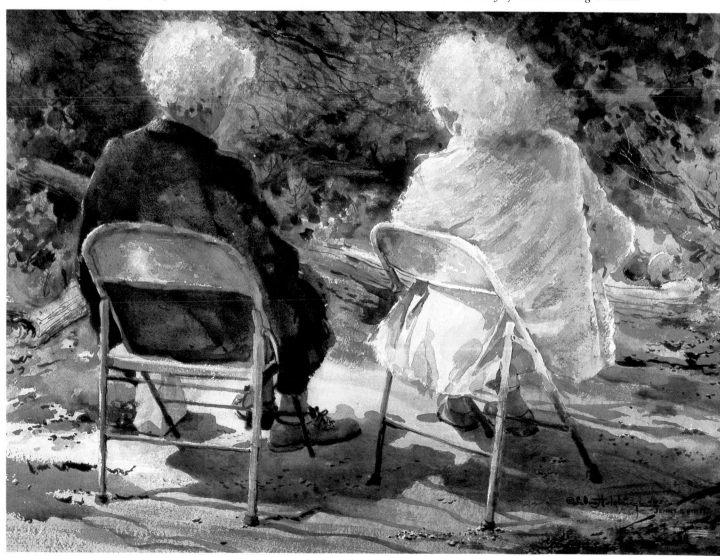

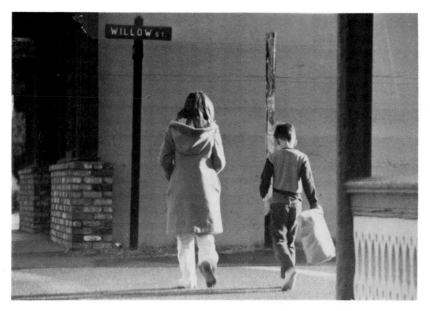

"Sunshine"
8" × 11" watercolor,
140-pound Arches cold press
Collection of the Artist

SIDE LIGHTING

Photograph
Step 1.

I often shoot black-and-white unposed photos of figures and animals. Sometimes the background is usable; sometimes I have to come up with a totally new composition. Sometimes subjects can be put into two different paintings. I used the little boy in another painting. See page 9.

Composition Sketch
Step 2.

I did the sketch from the photograph. My aim was to get rid of the geometry of the straight lines and make the background texture match the texture of the girl's coat. I wanted a composition that would make the figure pop out—be the center of interest. If I would have left those hard lines behind her, it would have been too busy; there would be too much competing with her.

Finished Painting

When I started painting I got so excited about what was happening I didn't want to quit so I just stayed with it until it was done.

I created the big curved areas in the background to help tie the girl to the background, and to create movement. If I had left the sign and boards up, there would have been a hard geometric background that would have ruined the emotion of the piece. I wanted it to be soft—a repetition of the girl's coat. Though I did *suggest* geometry with a few brushstrokes for the sidewalk and bricks after the painting was dry. This created a nice combination of hard and soft edges. I had planned to put more in the background, but after I got these details in, I saw that they were enough. By just putting suggestions in the background I accomplished what I wanted and at the same time created color and texture continuity between figure and wall.

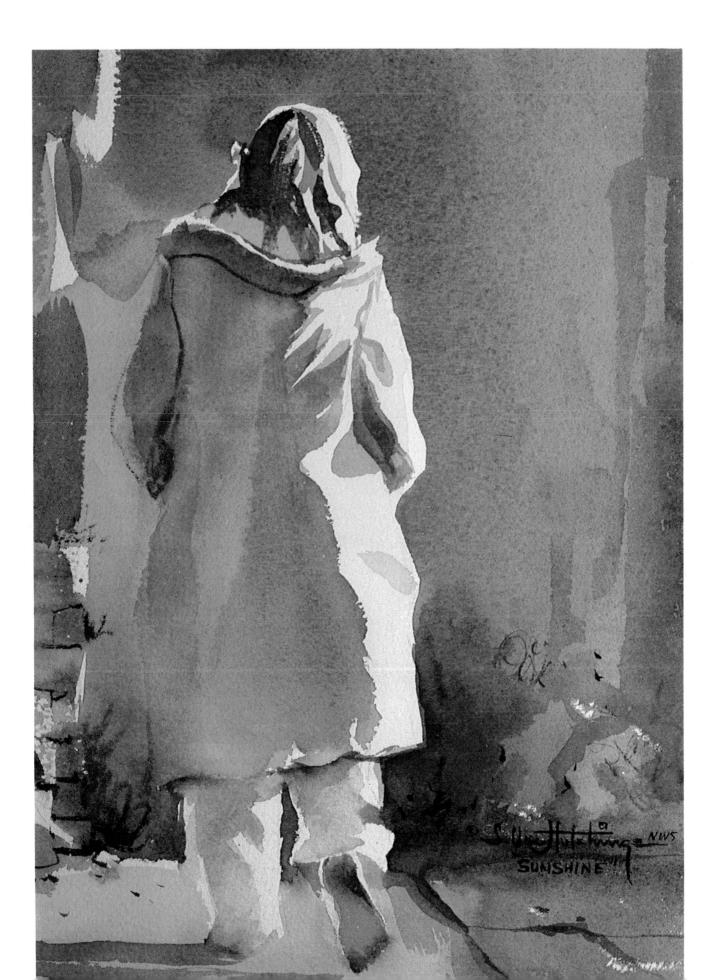

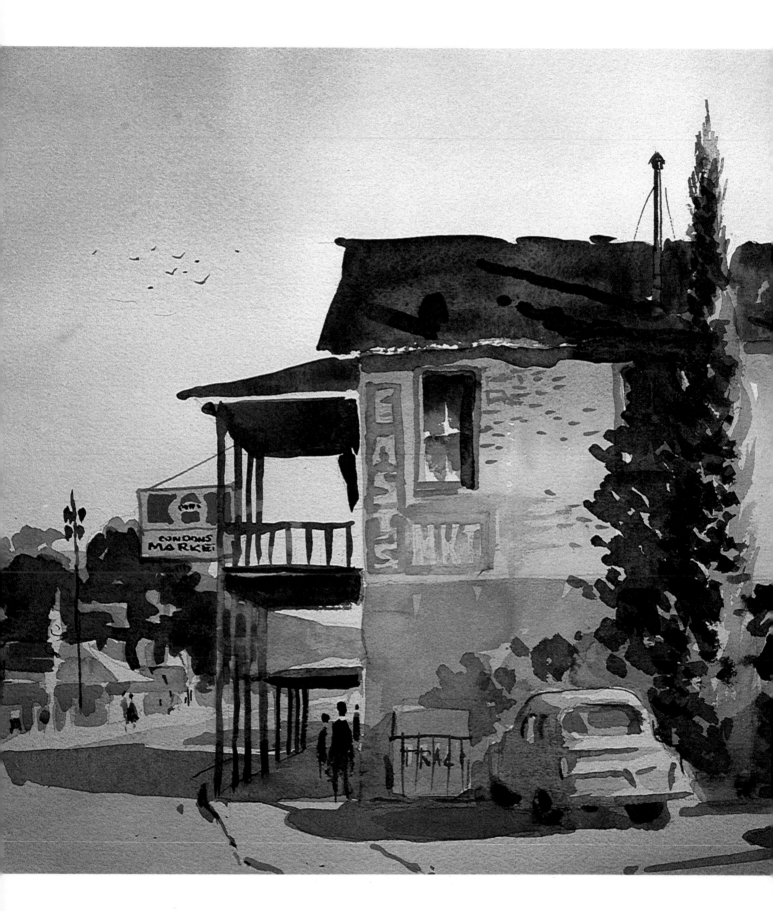

"Condon's Market": Overhead side lighting

"Condon's Market" demonstrates how shadows can contribute to the design of a picture. This painting would be dull without the shadows cast by the buildings, cedars, and car. These, as well as the smaller ones on the tree, car, and buildings, create a sense of depth. Their dark tones and cool colors help make the light-struck planes pop out, giving them a convincing sense of solidity.

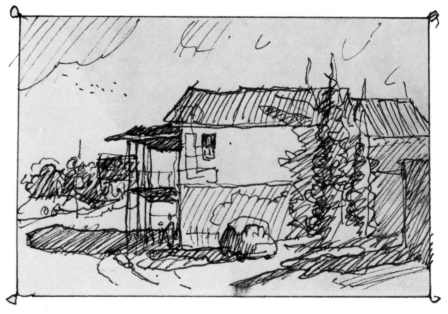

Shadows sketch

This could also be called a value sketch. It helped quickly determine not only interesting placement of shadows, but other values as well.

"Condon's Market"
15" × 22" watercolor,
300-pound Arches cold press
Collection of the Artist

BACK LIGHTING

A kind of lighting I find particularly interesting is back lighting. It's not as easy to see as lighting from other directions (side, top, or front), but it shows up in photographs.

A backlit subject presents a dark shadow side to the viewer with a halation of light outlining its contours. It's important to differentiate subtle value differences that occur in the shadow area within borders of the surrounding back light halo. Although the shadow is dark compared to the brilliant halo light around it, it's not a silhouette.

I've noticed beginners tend to make the shadow too dark and muddy. Remember that reflected light will almost always bounce up into the shadow from nearby reflecting surfaces.

Step 1.

My wife Anne cut this bouquet of lilacs and roses and placed it in this old white china teapot on my work table. The sunlight coming through my high window provided the major light source for this back lighted subject. Some additional top light came from my overhead fluorescents; this simply added to the light along the top edge of the bouquet.

I sketched directly onto the 11-by-15-inch paper, washed it with a light, warm gray wash, and let it dry. Only grayed violet and light yellow green (Winsor green and yellow) were brushed on in this step. Notice the sketchy drawing of vase, flowers, table, and shadow.

Step 2.

I saved my whites by using a masking fluid. It was applied only on the highlight areas, where sunlight seemed to come right through the petals, base, and table patterns. No salt was added. When the masking was dry, I painted the red roses with a variety of mixes. On the cool blossom to the right, I washed on a light value of Winsor red, then glazed Winsor red, medium value and added 50 percent violet to 50 percent Winsor red for the dark accents. The lighter roses were washed with a mix of yellow orange, three parts new gamboge plus one part scarlet lake, thinned with water. Glazes of the same yellow orange, grayed with a touch of violet, added accents.

The yellow roses began with a wash of new gamboge. Glazes of pale Winsor blue, pale violet, and pale Winsor green added color continuity. The yellow rose in shadow was glazed with grayed cool violet, one part burnt umber plus three parts violet. Burnt sienna was touched in, as was scarlet lake, for color accent and continuity.

Step 3.

I added some darker greens for color balance, using Winsor green mixed with burnt sienna.

Even though my worktable is dark, the light shining down on it creates a beautiful area for flower reflections. I wet this part of the painting and brushed the flower colors into it. Notice that I took some of the masking off to check the effects after I had brushed a grayed green background behind the bouquet. Some grayed violet was dropped in near the table top. I added darker reds to the rose.

Finished painting

Mixing one part burnt umber with two parts Winsor green, I painted dark leaves for more contrast behind the blossoms. I always try to get a variety in my color mixes by varying the proportions. Two parts burnt umber plus three parts Winsor green make greener leaves; three parts burnt umber plus one part Winsor green create a dark brownish green cast. Some of the leaves are a mix of three parts thalo red plus one part thalo green for color continuity and to add zest by putting warm color against a cool, gray background.

"Anne's Bouquet"
11" × 15" watercolor,
140-pound Arches cold press
Collection of the Artist

SIDE AND BACK LIGHTING

Compared to front lighting, side and back lighting reveal three dimensional form more convincingly.

Of course, most lighting is not 100 percent pure back, side, or top, but a little of one and a lot of another.

Early morning and late afternoon side lighting provide two favorite painting times for me. I love shadows—especially long shadows. They seem like long fibers that tie a fabric together.

Step 1.

In "Banty Rooster," hard edges predominate. This is an example of lost and found edges, as the eye follows around the perimeter of the square. The texture was done with the side of a flat brush.

A careful drawing from a black-and-white photo was necessary for this kind of rendering. I used an HB pencil, and then I put a delicate yellow green wash over the paper and let it dry. The cast shadow pattern was drawn so that it enhanced the overall design and created depth.

Step 2.

I used yellow ochre and burnt sienna for the head, neck, and back. A delicate wash of yellow, tinted with Winsor green, was washed on back and tail. Grayed violet washes on legs, tail feathers, and shadows created a darker value. Winsor blue created cool against warm on breast, sides, and tail. Some tail feathers were blended from a warm dark gray to Winsor blue, suggesting a reflection of blue sky.

Step 1

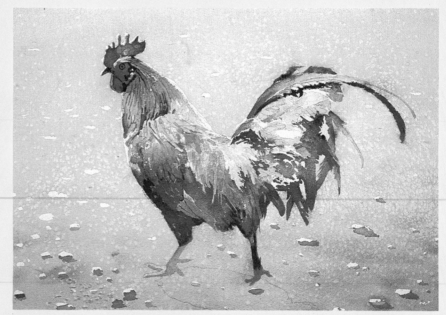

Step 2

Finished painting

I wanted a darker, more textured background, so I used masking fluid for the pebbles. I painted around the bird, leaving a halo on the sunny left side. The overall picture wash was gray violet, with Winsor green for the top half of the painting and more grayed violet for the bottom half. A few grains of salt were placed in the rock area for subtle texture. When the paint was dry, I brushed the salt away, removed the masking, and painted the shadow side of the rocks, using colors in the rooster. Final darkening, with dry brush strokes of color for small feathers and a big wash of grayed violet for shadows on the ground, finished the piece. Color continuity and color balance are part of the success of this watercolor.

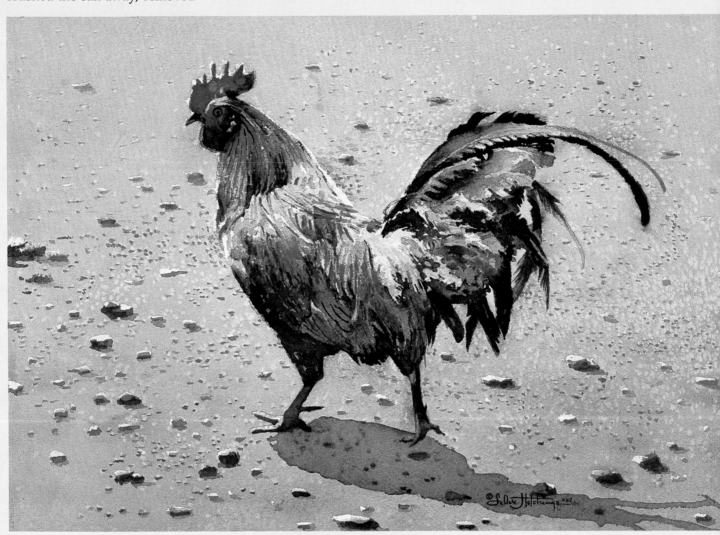

"Banty Rooster"
15" × 32" watercolor,
300-pound Arches cold press
© *Haddad Fine Arts, Inc.*

TOP LIGHTING

Strong top light simply means that the light comes from above. Above the cloud cover the sun still shines, and even though it comes through clouds, it still lights up the world.

Under cloudy skies, cast shadows aren't as evident. Also, with no side lighting, building walls become monotonous. Shadows do still exist, though, under eaves, canopies, awnings, and other things blocking the top light. If you were standing outside, your cast shadow would be directly under you but it would be light and indistinct.

However dull the sides of things may be, the top planes really pop out under top light, especially when wet. Distant roofs appear almost white, as will wet roads, highlights, puddles, wires, shrubs, trees, and fences. Black umbrellas look amazingly light when wet, as do people's heads, shoulders, and feet.

Indoor top lighting has the same basic effect on still life and models. However, since the light of an overhead lamp is not as diffused as outdoor light on a cloudy day, shadows will be more evident.

"Hornitos"

It was an overcast day with top light when I started this painting, but the sun soon poked through just enough to create a few illusive shadows. Still, the tops of everything were lighted, leaving the sides in shadow. The figure and dog were both silhouetted.

I sketched the design in pen, designating the three main values. I was concerned with balance and placement of center of interest.

I used all eleven colors on my palette. Initially, I wet the paper with pale yellow, and dropped in red and blue for color continuity. No salt or masking were used. Winsor blue, for the sky, reflected on all flat surfaces. Yellow ochre, burnt sienna, and alizarin crimson were used for warm areas. Violets were used for dark sides and water reflections. As usual, burnt umber accents helped tie the scene together.

Center of interest sketch

This sketch helped me quickly work out the center of interest.

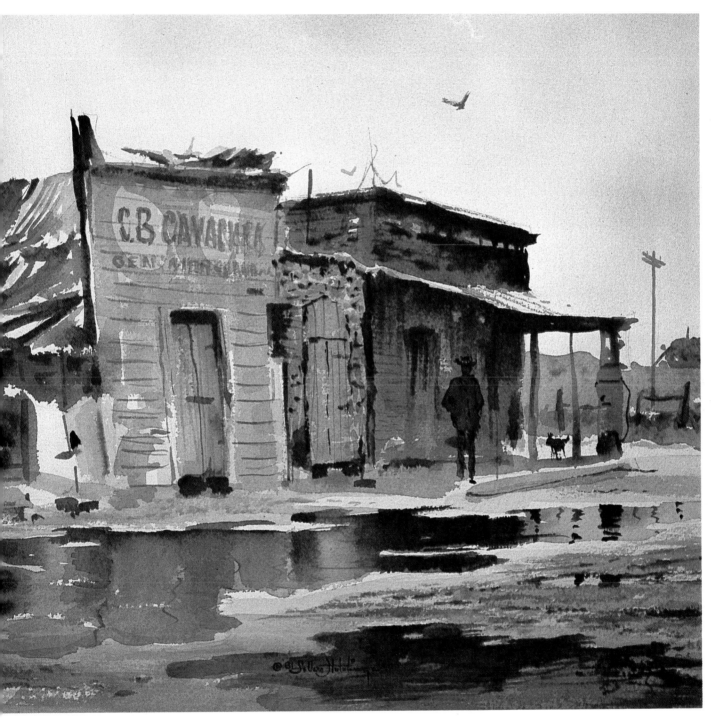

"Hornitos"
15" × 22" watercolor,
300-pound Arches cold press
Collection of Anita Schryver

LOW LIGHTING

Step 1.

I began with a pen sketch made at the site through my car windshield. At home, I copied it onto a sheet of 140-pound stretched Rives cold press paper.

My aim was to paint a fresh, dramatic street scene. First I put on masking agent to save the desired white areas. This was done carefully for the figures.

A new gamboge yellow toning wash over the whole picture created the basic mellow mood. Reds and blues dropped into it made for color continuity. When the time came for color coding, I used scarlet lake on the store front. Also violet and burnt sienna were added to buildings and pavement while the paper was still wet. Some salt was added. The painting dried thoroughly, and the salt was scraped off.

Step 2.

I used big, wet glazes of Winsor green and burnt seinna for trees, dropping in scarlet lake and violet while the glaze was still wet. I salted it slightly. Distant trees were a mix of Winsor green and Winsor red. The building with the balcony was glazed with violet, burnt sienna, and scarlet lake. Cars and windows in shadow were done with Winsor blue. Signs were Winsor red. The long Winsor-blue-and-violet shadows on the street carry the eye into the painting. Touches of yellow ochre and burnt sienna were added to the rusty roof and weeds at the right. Finally I removed the masking.

Step 1

Step 2

Finished painting

After adding more new gamboge to suggest a sunshine feeling, I worked on the tree area, adding more Winsor colors—green, blue, and red—along with leaf textures. I used nearly all of my palette colors in the parking lot trees—greens, reds, violets, oranges, blues, and yellows. Notice the red orange foliage against grayed violet just above the two smaller buildings.

Next came the figures. They re-quired much care to make them believable and yet loose and luminous.

The texturing and details on roofs and store fronts give them a realistic, finished look. Burnt umber touches and accents have created trunks, limbs, and dark shadow areas. I like this side-lighted painting, not only because it came off, but because my little gold rush town is being modernized. The red store is gone, and they're changing the others. So this painting is my version of what used to be.

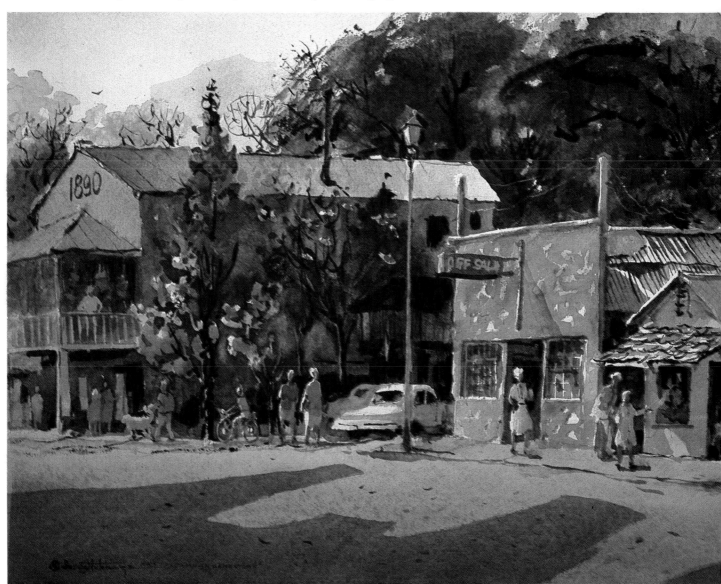

"Autumn in Jamestown"
22" × 30" watercolor,
140-pound Rives cold press
Collection of the Artist

NATURE'S SUBJECTS

I'm convinced what really turns the watercolorist on are nature's wonders: clouds, water, snow, mountains, and trees. I've never met anyone who wasn't enthralled by the outdoors, but the artist and poet seem to be best equipped to express such feelings.

CLOUDS

White clouds floating in a blue sky have a delicate beauty. Most clouds aren't pure white but reflect the atmosphere. I'm always intrigued by their shadows, which change and mix with light-struck areas and sky blue. Painting clouds is a delightful endeavor.

Here are a couple of points I've learned about painting clouds: (1) Shadow color brushed in while both clouds and sky are wet will tie the two together and create depth and form. Any delicate gray can be used; (2) Clouds reflect the ground color, sun color, atmosphere, weather, and season. Often you can key your total painting to the type of sky.

"Summer Rain"

I've always been awed by this type of cloud display. After penciling in the composition on a half sheet of Strathmore's best 300-pound cold press paper, I brushed in a delicate blue mountain, using Winsor blue. Then I put a pale new gamboge wash in the sky area.

The clouds were done wet-in-wet with a 1½-inch flat brush. A gray-rose area, one part permanent rose and one part burnt umber, thinned with water, was put into the lower left area. While this was still wet, I mixed one part burnt umber with one part burnt sienna and stroked the

long rain clouds, moving from top downward, letting the bottoms bleed and soften into the lighter sky. Adding a little bluish umber (two parts French ultramarine blue plus one part burnt umber, thinned), I stroked in the long clouds on the right.

By this time, the water was evaporating. Using the same bluish umber, I made several short strokes that stayed put—didn't blend. These dark staccato clouds made the sky more dramatic.

I saved the whites on the roof and fields to show top lighting. Distant trees and dark foreground modeling were glazed in next.

Final accents were done with one part burnt umber and one part violet for building and foreground, and one part burnt umber and one part Winsor green for middle-ground accents. Distant trees were also done with the two mixes just described. Both mixes were thinned with water in relation to distance. The only bright greens were Winsor green, grayed with a touch of violet just above the barn. This building was washed with pale burnt sienna and glazed with light, medium, and dark values of burnt umber.

Even though the sky is gray, all the ground colors have bounced into it, creating color continuity.

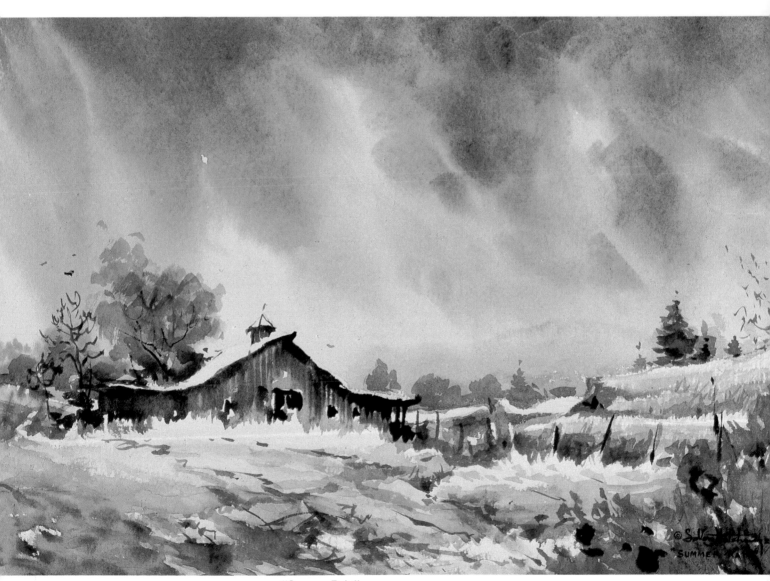

"Summer Rain"
15" × 22" watercolor,
300-pound Strathmore Gemini cold press
Courtesy of Tonian Hohberg Collection

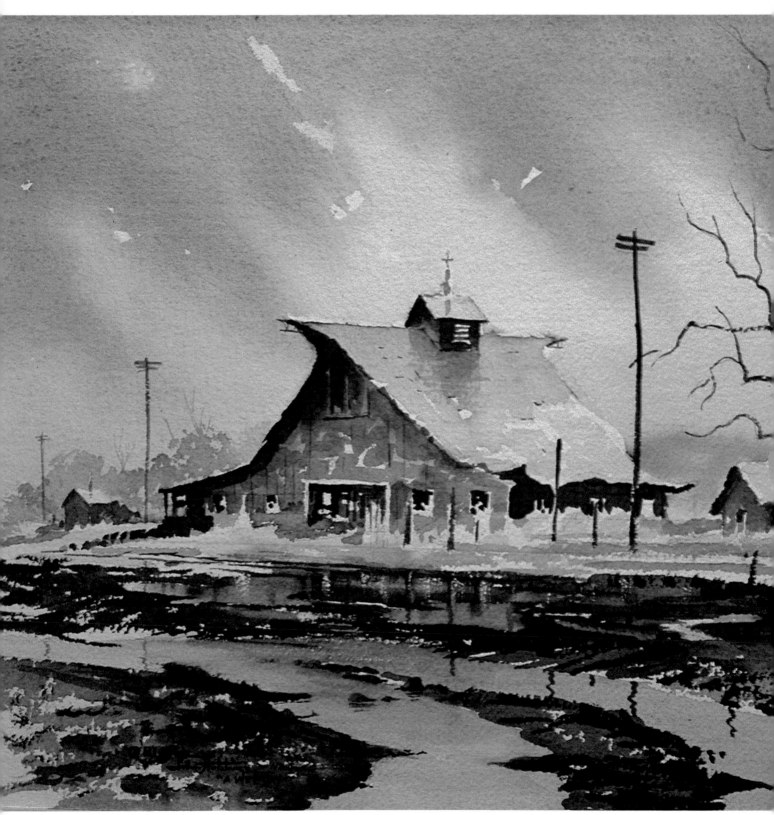

"Wet Day," 11"×15" watercolor, 300-pound Arches cold press, Collection of Gail and Jim Pitts

"Wet Day"
Composition Sketch

After making several pen sketches from my car, I selected this one to use to paint in my studio.

Stormy clouds have always intrigued me. After years of studying and painting them, I've concluded that their color structure is made up of yellow, burnt umber, and violet.

Finished painting

I used new gamboge mixed with burnt umber for the light areas of the sky and puddles. Winsor blue was blended into the puddles at the bottom of the picture. Violet and burnt umber made the darker clouds. Winsor green and new gamboge provided foliage coloration, and yellow and cadmium red brightened buildings and reflections. Roof reflections were done with darkened cloud colors. Puddles, reflections, banks, posts, trees, windows, and other accents were done in burnt umber. Notice that I preserved many white paper areas throughout the picture to suggest the sparkle of wet reflections.

WATER

" 'M' Street, Merced"
Step 1.

It rains a lot during the winter in northern California. My workshop class had gathered with me on a sidewalk under an awning. I made a pencil sketch as a demonstration, then painted the watercolor back in my studio.

Winter skies seem to be yellow and violet with the same colors reflected into wet areas.

Burnt sienna was used for the autumn leaves. While the work was wet, I touched in areas of burnt umber and new gamboge with a few quick accents of scarlet lake. The darkest buildings were painted with mixtures of warm browns. The building across the street was done in warm grayed violet—one part French ultramarine blue plus one part permanent rose with a touch of burnt umber.

Finished painting

Buildings on the corner were done in burnt sienna with alizarin crimson dropped in. The tall center building began with a graded burnt sienna wash that was darkened under the eaves with burnt umber charged with alizarin crimson. Winsor blue in various strengths was used for roof, windows, and signs. My aim was to create a warm, rainy street scene—top lighted and happy. Also, I wanted to have brightly dressed people in the scene with their colors reflecting onto the street.

I was concerned that the strong diagonal line of street and curb would pull the eye out the lower right-hand corner of the picture. To counter this movement, I added strong vertical lines, brightly colored figures moving the other way, and a large tree that helped to stop the movement out the corner and turn it back to the center.

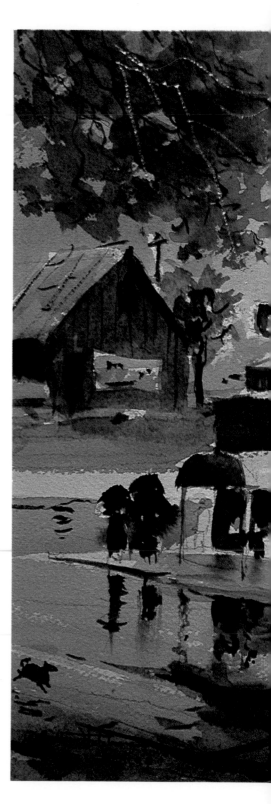

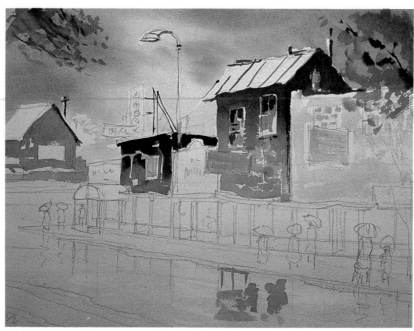

Step 1

100

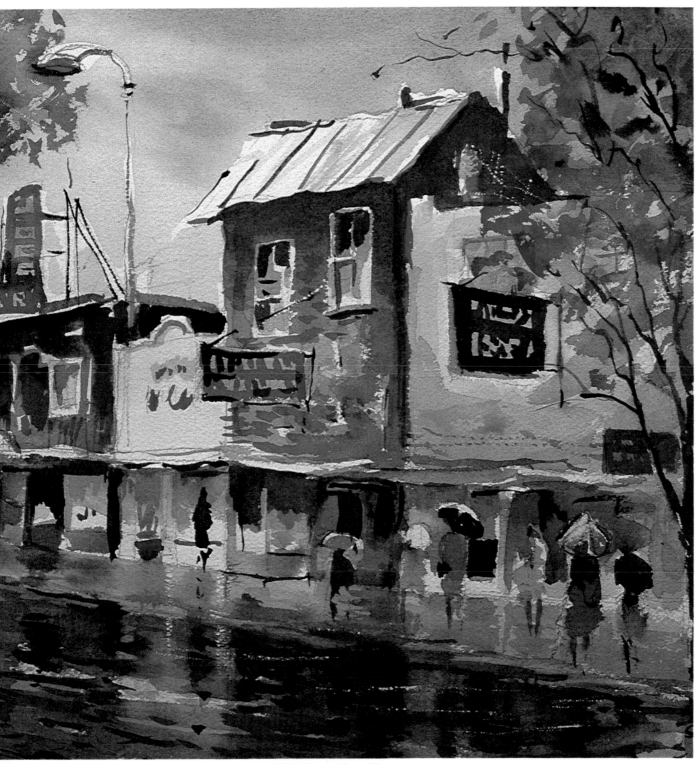

" 'M' Street, Merced"
15" × 22" watercolor,
140-pound RWS cold press
Collection of the Artist

"Churches in the Rain"
Step 1.

I soaked a sheet of 400-pound J. Green cold press paper for fifteen minutes, then stretched it onto a piece of three-quarter-inch, shellac-treated plywood.

After drawing in the scene from a small pencil sketch, I washed in the sky, using new gamboge yellow, grayed violet, and burnt sienna to paint around the buildings. When this was dry, I began to paint the shapes of the buildings, which are all top lighted. The darker sky and red foliage made the white roofs pop out.

Step 2.

Next I went one value darker and painted windows, details, and decorations. In reality, I was almost finishing a section at a time. This method is not usual for me, but it worked this time.

Finished painting

All I needed now was to make the foreground work. I painted slowly and carefully, using clean, bright reds and oranges with yellow. The pale mauve washes in the foreground repeated the sky color. Winsor blue on the roofs was repeated many times in the foreground, as was the church and tree color.

As I painted, I checked to see if I was maintaining luminosity. I didn't want a muddy painting, so I kept the palette clean and limited the number of glazes to three.

I cropped both left and right sides of the picture to make the churches more dominant. I added the figures in the corner to help lead the eye into the picture. I did quite a bit of glazing in the foreground to show wet ground, water, and reflections. The dark buildings acted as foils against the lacy autumn foliage. The two figures were interesting, dark accents in the overall design.

No salt or masking were used. A few knife scratches gave sparkle to the foliage at the left and left center.

Step 1

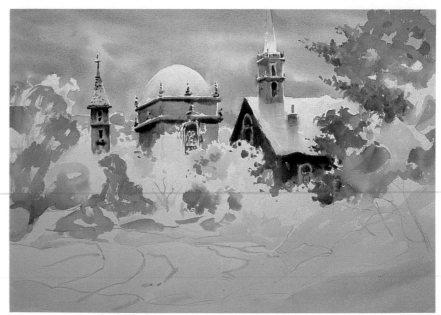

Step 2

"Churches in the Rain"
18" × 23" watercolor,
400-pound J. Green cold press
Collection of Mr. and Mrs. Peter Jeppson

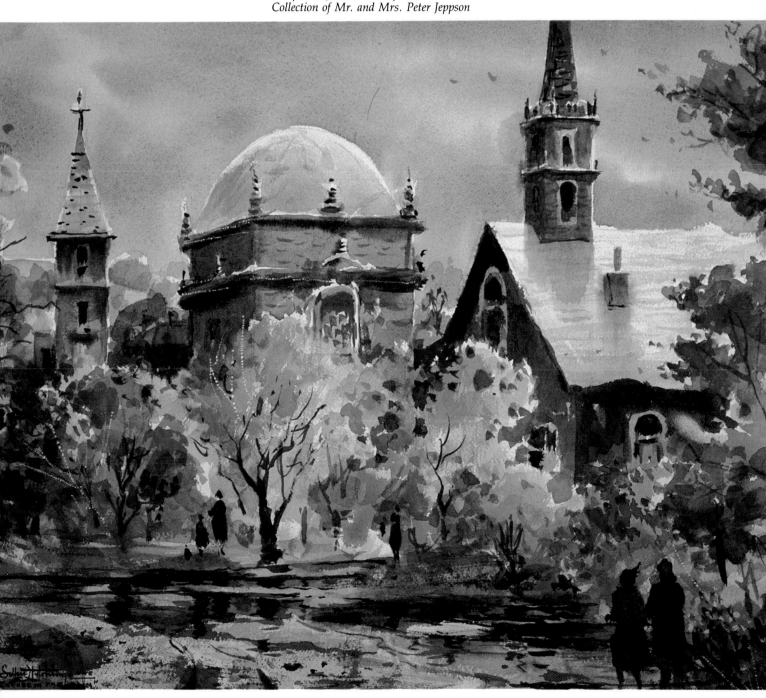

"Puddles"

This scene, after a heavy rain, had a melodious pattern of elliptical, irregular puddle shapes that contrasted nicely with the angular, straight-edged building. Here's how I went about recording it.

A delicate underpainting, using a mix of Winsor green and Winsor red, was brushed on and left to dry. Next, I glazed a pale Winsor green onto the sky area; for storm clouds, I flowed a mix of burnt sienna and violet onto the sky while it was wet. Three layers of distant trees were glazed on; I waited for each one to dry before adding the next. Some of the grayed violet used for the trees was mixed with burnt sienna for the middle and foreground earth colors. I sprinkled salt in the left-center foreground for textural balance.

Distant buildings, poles, and posts were rendered next, with their reflecting top light.

Next I painted middle-ground buildings. I tried to keep my color lively by putting warm against cool and using complementary colors side by side. Attention to puddles took precedence. I showed building reflections, saved whites along edges, and accented shadowed sides. Final touches included the careful rendering of the man in the yellow slicker with his dog.

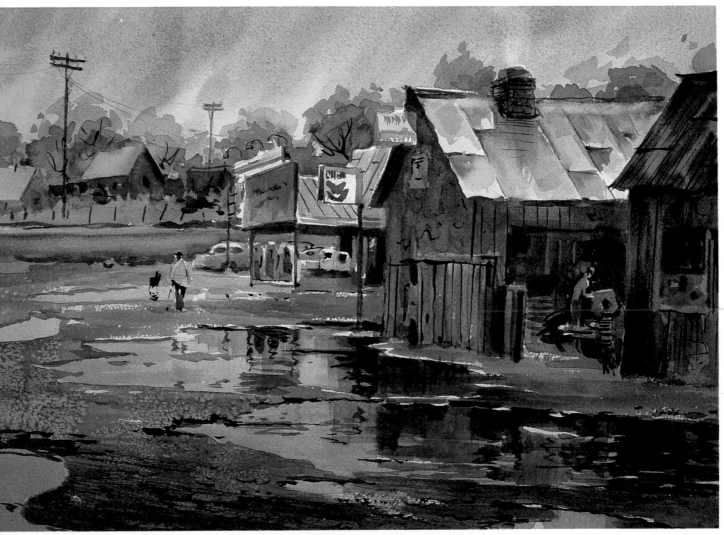

"Puddles"
15" × 22" watercolor,
140-pound RWS cold press
Collection of Mr. and Mrs. Jack Robinson

SNOW

"Tuolumne Winter"
Step 1.

"Tuolumne Winter" was drawn and painted directly from this black-and-white photograph. The composition is similar to the photo's, but some changes have been made. For instance, I think my road is more interesting. I had to rearrange, add, and delete. There were also value changes.

Step 2.

After carefully drawing the elements, I washed sky and foreground with a pale violet, brushing in burnt sienna and violet clouds. No masking or salt were used.

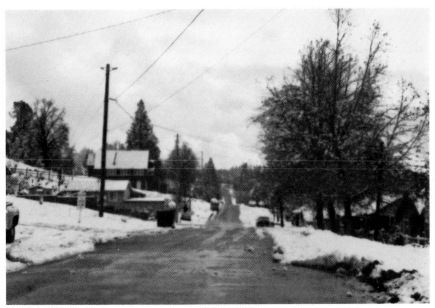

Step 1

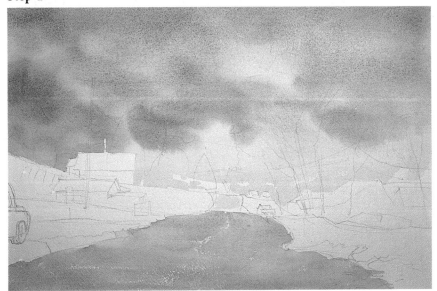

Step 2

Step 3

Step 3.

After the sky wash dried, I applied dry-brush glazes of mountain, trees, and buildings, adding grayed yellow for the tree mass on the right and the small buildings. The dark pine tree on the left was a gamble. It seemed too big and dark, but it dried lighter and looked fine.

To simplify the design I left out telephone lines, most cars, and some buildings. I also pushed the distant trees and mountain back with value and color.

Finished painting

I mused over the proper way to do the road. The snow was melting and would all be gone in a few hours. I decided to try a varied gray surface, realizing that top light affects both water and asphalt. When I dry-brushed the gray around the puddles, I varied the warm and cool values with earth colors and grayed violet. A few judicious touches of accent at the sides of the puddles added liveliness. Tree trunks, fences, poles, and foliage needed a darker value of burnt sienna. The cars were put in last. The one on the left border helps balance the large weight of the tree mass at the right. It also helps to create depth because it's so much larger than the green car down the right side of the road. The birds add a touch of life and movement.

"Tuolumne Winter"
15" × 22" watercolor,
140-pound Arches cold press
Collection of Brigham Young University

**Finished painting
"Winter Rhapsody"**

I began this painting with the sky, down to the area behind the pines. To give it punch, I added more blues and delicate grayed violet shadows. When I lost my whites, I took a tissue and dabbed out the white cloud patterns.

After the sky dried, mountains were glazed on. Careful rendering of pine trees was next. I started with pale grayed blue trees and darkened the values on trees in the foreground, remembering to use warm earth color for vibration. Winsor blue shadows, water, and accents in trees created color continuity. Light and shadows helped to tie the foreground together and give it interest.

"Winter Rhapsody"
15" × 22" watercolor,
300-pound Arches cold press
Collection of the Artist

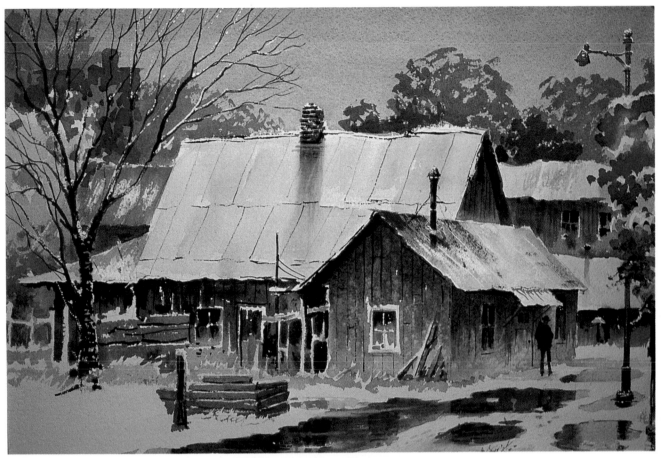

"Snow in Jamestown"

It snows in Jamestown, California once or twice a year. This painting captures one of those times. As you've probably guessed by now, top lighting like this fascinates me. There were no sun, moon, or street lights, but light filtering through clouds gave everything a calm, distinctive look. All shadows were soft. Wood was wet and dark, especially tree trunks, posts, and under-eave areas.

Values were important because all the color was grayed: contrast and emphasis depended mainly on the value structure.

I mixed Winsor green and alizarin crimson to get the silvery gray of the distant tree, adding burnt umber and sienna to closer foliage. Most wood was painted with earth colors. I used blue for windows, shadows, and sky reflections in the snow puddle. All darks were done with burnt umber. Sky colors were reflected subtly onto the snow. Chimney reflections added realism, as did reflections into wet areas. The one lonely figure added human interest.

"Snow in Jamestown"
15" × 22" watercolor,
300-pound Arches cold press
Collection of Mr. and Mrs. Dennis Dickson

"Late March"
Composition sketch

The initial pen-and-ink sketch for "Late March" created a simple abstract design that resulted in a good composition.

Finished painting

Color-coding was helpful. I laid a yellow wash into the sky and water areas, leaving the white design made by the snow banks. I color-coded distant blue violet tree masses, middle-ground burnt sienna trees, and the burnt umber and French ultramarine blue for ground, trees, and water. Most color was grayed. This technique gave the painting a feeling of softness and let the violets and blues blend throughout with their complements—siennas and yellows.

The darkest tones—burnt umber and French ultramarine blue—were dropped in full strength while the paint was wet. Burnt umber calligraphy and knife scratches were added when the washes were dry.

"Late March"
15" × 22" watercolor,
300-pound Arches rough
Collection of the Artist

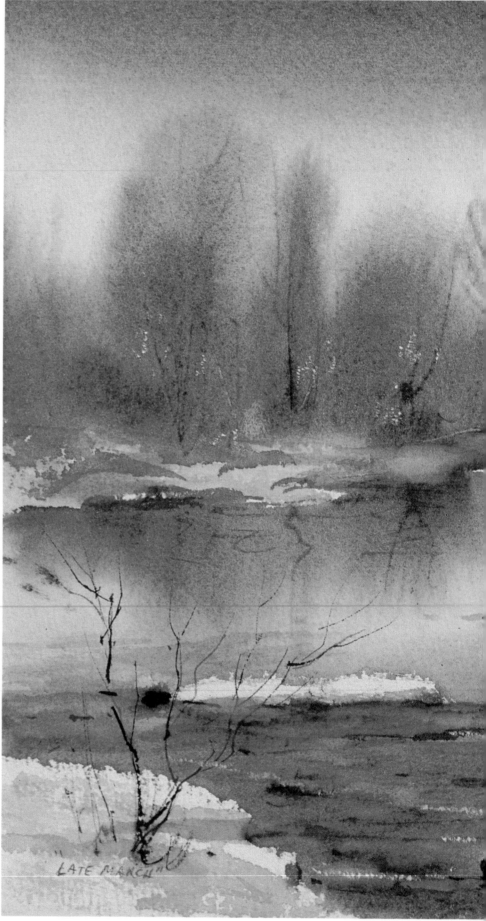

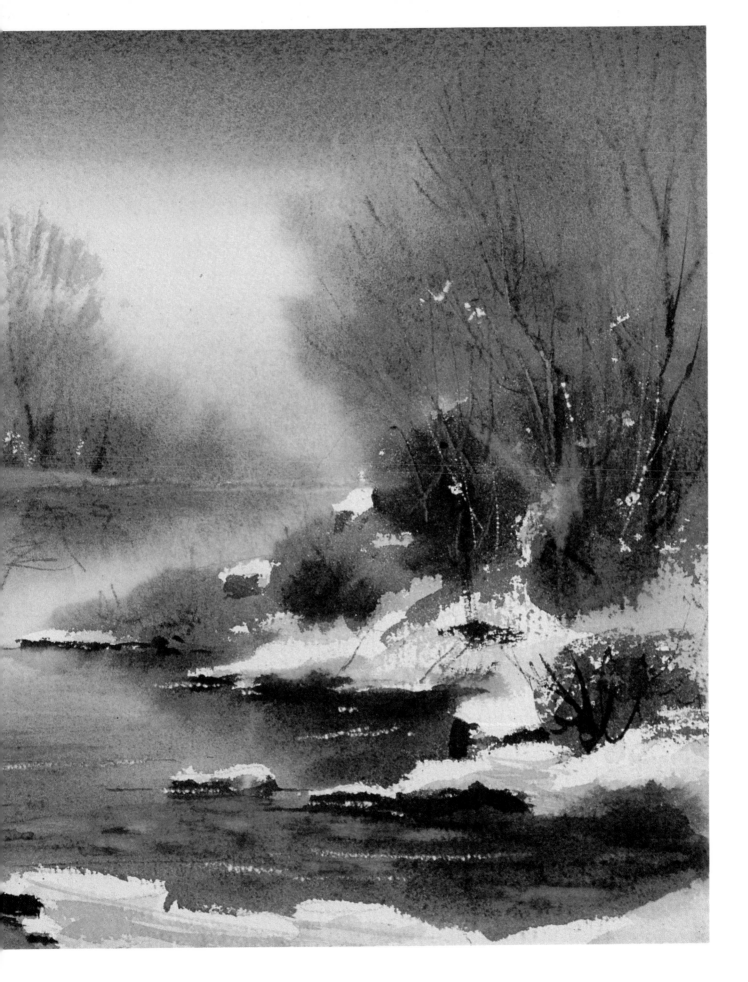

MOUNTAINS

"Green Ice"

I gave this pale Winsor red toning wash, and dropped in a turquoise (Winsor green and Winsor blue) sky while the red was wet. The distant mountains were painted into wet pink clouds, giving them a soft, hazy look.

The middle-value grayed violet hills were glazed on next. Pine trees were done with Winsor green, toned with yellow, Winsor blue, and burnt sienna. The green ice was a repeat of sky color. Grayed violet shadows, tinted with other colors, created the shadows cast from the trees. The dark accents were indicated with burnt umber.

"Green Ice"
22" × 30" watercolor,
400-pound J. Green cold press
Collection of Jeffrey C. and Patricia A. Hennings

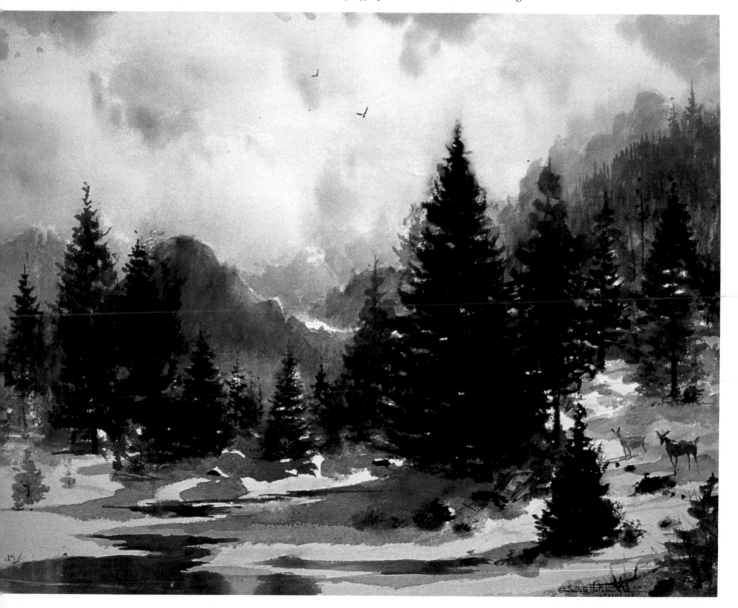

Step 1

TREES

"Holiday in Mendocino"
Step 1.

After making the initial drawing on stretched Whatman paper, I masked out whites I felt would be hard to paint around—statue, trim, poles, windows, figures, trees, and such foreground surface items as rocks, ruts, and grass. The initial pale new gamboge toning wash gave things a sunny look. While it was still wet, I color-coded it with appropriate local color, as shown, including red-yellow-blue for color continuity.

Step 2.

Since I wanted a high key painting, I purposely used delicate glazes for distant trees, roof, statue, and bushes. I repeated sky colors throughout the rest of the painting to create color harmony. Notice the layering of color in background trees. Aerial perspective is evident, even in these high-keyed delicate tones.

Step 2

Finished painting

I created distance between the far hill of trees and the middle ground by dropping in blue-grayed violet. This color also makes anything that is orangish vibrate. I experimented with the windows to see if a variety of colors in their panes would work. I liked the effect.

At this point, the painting was finished except for texturing, accents, and minor corrective passages. I purposely omitted most detail from the figures at bottom left. Too much color would have pulled the eye there and created imbalance. Instead, I added more color to the other figures. Texturing of road, tree on right, bushes on left, roofs, windows, poles, and figures was my final act. I made the dog less obvious by painting him a washed-out gray.

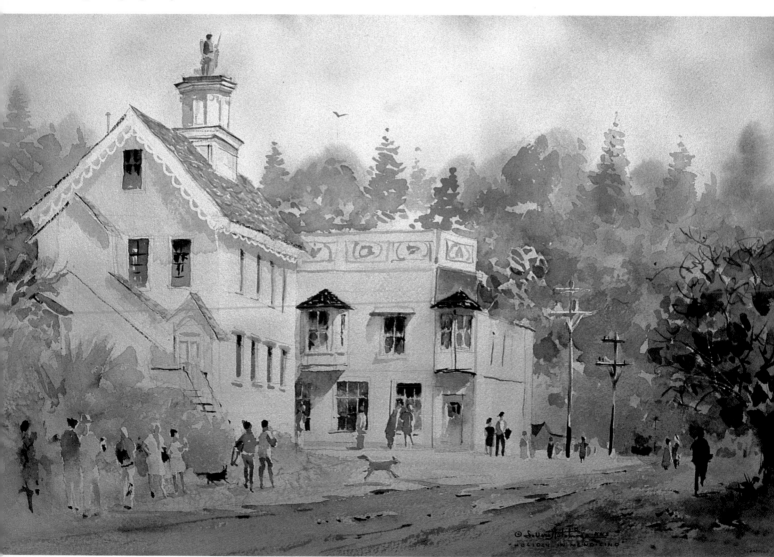

"Holiday in Mendocino"
15" × 22" watercolor,
140-pound Whatman cold press
Collection of the Artist

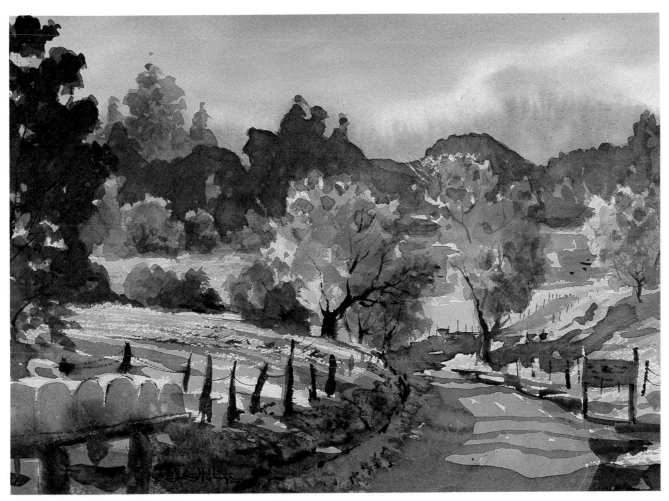

"Poverty Hill"

I like the way all kinds of artists paint trees. I'm intrigued by Grant Wood and Grandma Moses interpretations. I enjoy the way kids paint theirs. I like the simplicity of comic-strip trees, and the way realists show every limb and leaf. I'm overwhelmed by the lush trees of Durand, Cole, Corot, Sisley, and Innes. But no one understood trees better than John Carlson, the internationally known landscape artist whose trees had a lacy, poetic feeling. He's had a big influence on my work.

Trees are usually used as background or decoration for the dominant center of interest, but occasionally one will emerge as dominant. We need to be ready to do justice, to meet this challenge, by continually sketching, designing, and painting these beautiful living things.

"Poverty Hill"
22″ × 30″ watercolor,
300-pound Fabriano cold press
Collection of the Artist

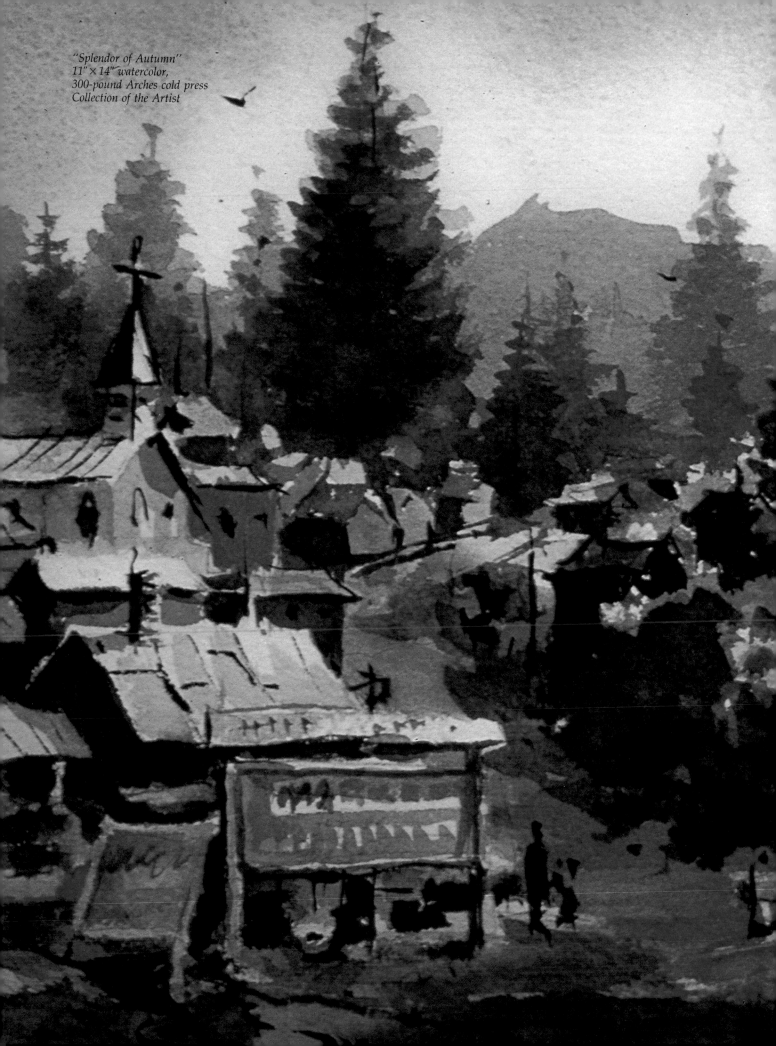

"Splendor of Autumn"
11" × 14" watercolor,
300-pound Arches cold press
Collection of the Artist

"Splendor of Autumn"

In order to achieve color harmony, I gave the paper a new gamboge yellow toning wash and let it dry. This yellow tone came up through all the colors and gave the painting a rich, sunny look.

The color scheme was yellow-violet, with some greens horning in on the autumn colors. I touched some cool blues into skies, mailboxes, and shadows. As usual, my violet shadows were permanent rose with French ultramarine blue. I was careful to reflect the sky cloud color down into the asphalt road, and bounce it onto mailboxes and shadowed areas.

SUMMARY

When painting a landscape, try to tie clouds, water, snow, mountains, and trees together in the following ways:

• *Use related shapes*. For example, repeat cloud shapes in water, trees, and earth.

• *Repeat the color scheme throughout.*

• *Use values that seem to be related.* Attention needs to be given to whether high, middle, or low key should predominate in a painting. The value structure should be related except when an unrelated value, like an extremely dark spot in a high-key sky, is used for emphasis.

• *Work to keep the mood consistent throughout.* Generally speaking, if a sky is angry and menacing, its color and feeling should pervade the painting. Seasons, time of day, and position of sun all affect the mood. For example, if you paint a spring landscape, you can create mood with soft fleecy clouds, blue sky, tender foliage, flowers, and clear sparkling water.

Austin, Phil. **Capturing Mood in Watercolor**. Cincinnati, Ohio: North Light Books, 1984.

Brandt, Rex. **Watercolor Landscapes**. New York: Von Reinhold, 1963.

Carlson, John F. **Carlson's Guide to Landscape Painting**. New York: Sterling Publishing, 1953.

Croney, Claude. **My Way with Watercolor**. Cincinnati, Ohio: North Light Books, 1981.

Faulkner, Ray, Edwin Ziegfield & Gerald Hill. **Art Today**. New York: Holt, Rinehart & Winston, 1963.

Fitzgerald, Edmond J. **Marine Painting in Watercolor**. New York: Watson-Guptill, 1972.

Gasser, Henry. **Technique of Painting**. New York: Reinhold Publishing, 1958.

Graham, Donald W. **Composing Pictures, Still and Moving**. New York: Holt, Rinehart & Winston, 1963.

Henning, Fritz. **Concept and Composition**. Cincinnati, Ohio: North Light Books, 1963.

Henri, Robert. **The Art Spirit**. New York: J.B. Lippincott, 1960.

Hill, Tom. **Color for the Watercolor Painter**. New York: Watson-Guptill, 1975.

Hoopes, Donelson F. **Winslow Homer Watercolors**. New York: Watson-Guptill, 1971.

Jones, Franklin. **Painting Nature**. Cincinnati, Ohio: North Light Books, 1978.

Kautzky, Ted. **Ways with Watercolor**. New York: Watson-Guptill, 1970.

Kinghan, Charles R. **Ted Kautzky, Master of Pencil and Watercolor**. New York: Reinhold Publishing, 1967.

Merriott, Jack. **Discovering Watercolor**. New York: Watson-Guptill, 1973.

O'Hara, Eliot. **Watercolor Fares Forth**. New York: Minton Balch, 1938. Reissue: New York: Watson-Guptill, 1969.

Olsen, Herb. **Painting the Marine Scene in Watercolor**. New York: Reinhold Publishing, 1967.

Palmer, Arnold. **More than Shadows**. Biography of Sir William Russell Flint. New York: The Studio, 1948.

Pike, John. **Watercolor**. New York: Watson-Guptill, 1969.

Prohaska, Ray. **A Basic Course in Design**. Cincinnati, Ohio: North Light Books, 1980.

Szabo, Zoltan. **Landscape Painting in Watercolor**. New York: Watson-Guptill, 1971.

Watson, Ernest W., and Norman Kent. **Watercolor Demonstrated**. New York: Watson-Guptill, 1946.

Webb, Frank. **Watercolor Energies**. Cincinnati, Ohio: North Light Books, 1983.

Whitney, Edgar A. **Watercolor: The Wheres and Whys**. New York: Watson-Guptill, 1958.